Introduction
to
Folk Art

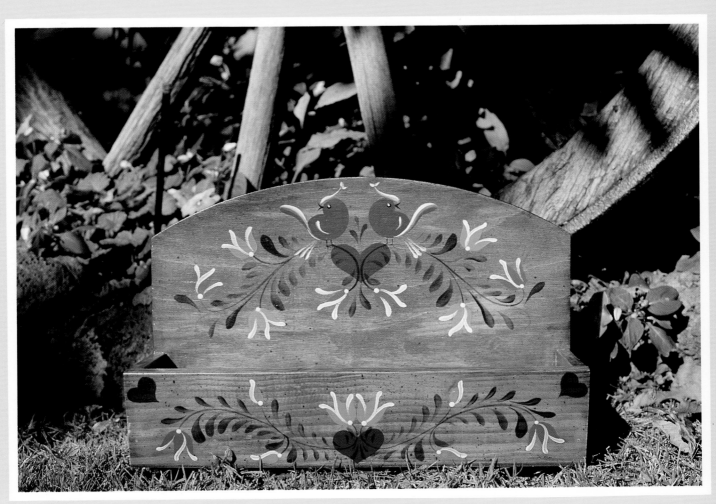

Wooden bird box (page 48)

Introduction

to

Folk Art

Lea Davis

Kangaroo Press

This book is dedicated to my brother, Colin Charlton (1956–1979),
and to my beautiful sister Sue Donald.

The Lord gave them to me as my family—
I would have chosen them anyway as friends.

Acknowledgments

Very special thanks to:

Philip, my husband, whose patience is as limitless as his love;
Mike and Tim, my sons, for their understanding and
encouragement; Peter, Casey and Scottie, for being there; and
Mum and Dad, for everything.

I am grateful also to have had the help and support of these
people:
 Carol and Sylvia of Craftee Cottage, Oakleigh, Victoria
 Karen Rowelle of C. & S. Imports, Melbourne and Sydney
 Sue Schirmer of VADA
 Sharon Bacon of Folk Art Tol'd, Melbourne
 Timber Turn Woodturners and Manufacturers of South
 Australia

John Dillion of Galmet Paints, Sydney
Phil Drew, my wonderful photographer (thank you for
 the loan of your husband, Val)
Carol Scott, my dear friend.

A special thank you to Enid Hoessinger, my teacher and
inspiration, and to Helene Werner, who started me on my Folk
Art journey.

My thanks to all my students, my friends, and everyone,
especially Carol and Sylvia from Craftee Cottage in Oakleigh.

© Lea Davis 1992

Reprinted 1993
First published in 1992 by Kangaroo Press Pty Ltd
3 Whitehall Road Kenthurst NSW 2156 Australia
P.O. Box 6125 Dural Delivery Centre NSW 2158
Typeset by G.T. Setters Pty Limited
Printed in Hong Kong by Colorcraft Ltd

ISBN 0 86417 429 2

Contents

Introduction

This book was written with the beginner in mind. It may seem too easy to some, but it is intended to be a basic guide. I have tried to cover the areas that I feel are important to students starting out on their Folk Art journey, without getting into too much detail.

I have kept the patterns simple to avoid confusion and frustration. Please try them. Too often a budding artist will pick up a pattern book and, daunted, put the book straight down. It is far better to successfully paint something simple than to get into difficulties with something harder.

Don't be discouraged if your piece does not turn out as well as you had hoped. Folk art is not a perfect art. The more you practice the more proficient you will become. Relax and enjoy the time you devote to practising. Don't look on that time as being wasted, rather as time spent helping you grow in this field. Remember, you learn from your mistakes.

Traditionally folk art was done by ordinary people to decorate their homes. Simple peasant folk mostly, farmers, hence the German word *Bauernmalerai*, 'farmer painting'.

These folk usually had no formal training in painting or colour mixing—rather, their techniques were passed down from one generation to another.

Different areas and countries developed their own styles. For example, *Hindeloopen* (traditional Dutch folk painting) uses traditional techniques, colours and designs, notably a tomato red background. The prevalence of scrolls in the basic style is also traditional. English canal boat painting, with its bright base colours of green, black, red or blue and wonderful stroke roses, was used to adorn everything, from the stem cabin to the coalbox, on the water-borne homes of the narrowboat people of Britain. *Alpbach* style is usually painted on stained wood in soft earth colours. Folk art is found in many different countries and has as many different styles.

Whichever style you choose to paint, and they are many and varied, remember that by application and hard work you have the ability to become a decorative artist.

Equipment

Paints and varnishes
Jo Sonya products:
 Paints
 Clear Glazing Medium
 Retarder and Antiquing Medium
 All Purpose Sealer
 Crackle Medium
 Flow Medium
 Polymer Finishing Varnishes

Folk Art Water-Base Satin Finish varnish and Folk Art Clear Cote spray-on varnish are also popular.

The Americana range of paints by Deco Art includes a crackle medium called Weathered Wood. Their paints have great coverage and are heavily pigmented.

Folk Art paints and mediums.

Most good craft stores will stock these or be able to order them for you.

Paint brushes
All the projects in this book can be completed using just three brushes—the round brushes Nos 5 and 3 from the Raphael Series 8200 and the liner brush No. 2 from the Raphael Series 8220.

Paper towel
Paper towelling folded over and dampened with water is a useful palette. Place the paint directly onto the damp towel—the paint will stay workable much longer.

Vodka or nail polish remover
For removing mistakes or booboos or dried paint from brushes.

Cotton buds
For removing mistakes as above.

Glass water jar
Gently tapping the ferrule of the paint brush against the side of the jar when rinsing helps prevent paint build-up at the ferrule.

Kneadable eraser
A wonderful eraser available from newsagents.

White ceramic tile
For use as a palette. You can also use an ice-cream container lid.

Rags
Plenty of them.

Pencils
3B for drawing designs, HB for transferring designs.

Scissors

Dishwashing liquid
For cleaning brushes, or use Folk Art Brush Plus, available from stockists of Folk Art paints.

Greaseproof paper
Unwaxed, for transferring patterns.

Transfer and graphite paper
Available as single sheets by Cabin Craft, or in sets of various colours, e.g. by Saral. Available from craft shops.

Steel wool
#0000 or #000 is usually needed for the final sanding before applying a paste wax.

Paste wax
My preference is for Busy Bee Beeswax Furniture Polish, from hardware stores.

Poly-sponge brush
Available from your local craft shop. Washes out in soap and water. Not for use with mineral spirit products.

Masking tape
Used for masking when painting borders, etc.

Sea sponge
Available from chemists and craft shops.

Posterman Metallic Pen
(Water-Based Pigment) Available in Gold and Silver

Tack cloth
A gummy cloth used to remove sanding residues. Available from good paint suppliers. Avoid those which contain wax or silicone.

Agnew's Water Putty
A water-based putty that is cheap and easy to use. Available from hardware stores.

Wood filler
Available from hardware stores. Bristol has a great range.

Sandpaper
You will need varying grades but #400 or #600 wet-and-dry are needed for the soft sandings. Keep all the old bits for the final sanding. Available from hardware stores.

Galmet Zip Strip Paint Stripper

Haloprime Metal Primer
Ironize C S
Epoxy Rust Paint
These last four items are available from hardware stores or by contacting Galmet on 008 226262 for a stockist.

Brushes and brush care

Choosing the correct brush for your needs can be very confusing. Rarely does a cheap brush perform adequately—it is very much a case of you get what you pay for.

The round brushes used in this book are the number 5 and the number 3 from the Raphael Series 8200; the liner is the number 2 from the Raphael Series 8220. These brushes are great for beginners. When you feel confident you may like to move on to sable brushes, but they are expensive.

You don't need a lot of brushes to paint beautiful strokes—learn how to use these three well.

Brushes are sold with a stiffening substance in them, and must be washed before you use them.

Cleaning
Changing the rinse water frequently while you work is the first step in keeping brushes in good condition.

To clean a brush, hold the bristles under warm running water to remove excess paint. Squirt a drop of dishwashing liquid or liquid soap into the palm of your hand and shampoo the bristles gently, avoiding turning or twisting the hairs round and round. Rinse and repeat. Press the brush gently on a piece of clean white paper and if colour appears, repeat the process. When you are certain no colour remains, shape the hairs to a point with a little dishwashing liquid or soap and leave them to dry with the soap still in them.

Store brushes with their bristles uppermost, or lying flat—never stand them on their bristles. I use large straws with the bottoms taped over to store my brushes—drop the brush, handle first, into the straw. This protects the hairs.

With careful brush care brushes will last a long time so it's worth the few minutes it takes to clean them properly.

Palette

A simple palette, one that I use all the time, is made from a square of paper towel folded in half. Moisten it well, but don't make it so wet that the water will pool up around your fingers when you press it. Lay the paper on a white tile and set out your paints on this. When the paper starts to dry out lift it up and spray the tile with water. Using this method paints will keep moist even in the hottest weather. You can save the palette by placing it inside a plastic airtight container with a small piece of damp sponge.

Preparation procedures for wood

Most of us are so eager to begin painting that we don't give enough attention to properly preparing the wood in the beginning. A properly prepared surface is a delight to paint on and will last many years. So spend a few extra minutes now and avoid disappointment later.

Safety

Always wear an apron or old shirt and a disposable mask when standing. Sanding out of doors saves a lot of mess, but if this is not possible cover the work area with newspaper and vacuum up the dust before going any further.

To do a good job you need not just sandpaper (400/600 wet-and-dry, and lots of it), but a tack cloth to pick up the dust, wood filler and/or Agnew's Water Putty (good if the surface is to be painted).

Old wood in good condition

If you are not sure whether the finish on an old wooden surface is good or bad, a simple test is to paint a small area with acrylic paint and let it dry for about two weeks. Place a piece of sticky tape over the paint spot and pull it off. If it removes the paint then you should prepare the surface according to the directions for wood in bad condition.

First clean off all the dirt and grease. Then using medium grade sandpaper sand lightly and evenly all over to give the new paint a firm base to adhere to. Using a sanding block saves time as well as your fingertips and enables you to sand evenly. When you come to a fiddly bit, simply wrap the sandpaper around your finger. You may have to start with medium grade paper and work down to fine grade. Try not to sand in circles—instead, sand with the grain. If there is a dent in the wood, put a few drops of water on it and hold a steam iron a little above the surface. The water will swell the wood and the dent will disappear.

Clean off all loose dust with your tack cloth and the piece is ready to be painted in the background colour of your choice.

Old wood in bad condition

If the finish of the old surface is chipped, cracked or peeling you will have to remove it with a paint and varnish stripper—I recommend Galmet's Zip Strip.

Always wear rubber gloves when you work with paint strippers, and work outdoors or in a well ventilated area. These products are extremely toxic and smell awful, so please use them carefully. Make sure you read and understand all instructions fully.

Remove any hinges, handles or metal knobs from the article. Apply the stripper and leave it for the required length of time, then use a paint scraper to remove the soft blistered paint. You may need to repeat the application of stripper if the paint is very thick. Use dry steel wool to remove any stubborn areas.

Finally, wash down with methylated spirit, using steel wool or a scouring pad, then wash with warm water and laundry powder. Allow to dry and sand lightly before applying the background colour.

New wood (raw or unfinished)

Remove any labels or price tags from the article—if they have left a residue use nail polish remover to clean it off. Fill any holes with wood filler and let it dry. If you intend to stain the wood make sure to use a filler that corresponds to the stained colour.

Recess any nails and fill these holes also. Sand lightly in the direction of the grain, or down the length of the piece

in the case of craftwood. You will probably need a medium to fine sandpaper. Be aware of any routed edges or end-grain and pay special attention to them. They need to be sanded first with coarse sandpaper or they will look bad.

If you are using a soft wood, e.g. pine, and it develops a dent, use the water trick. Place a few drops of water on the dent and hold a steam iron over it. The wood will swell and push out the dent.

You have a choice of background finishes—Jo Sonya paint plus sealer, Plaid Folk Art base paints, acrylic house paint, Folk Art Velvet base paint.

If the article you are working with is small you may mix the bottled or tubed Jo Sonya paint with an equal amount of Jo Sonya All Purpose Sealer. This way is the simplest as

you are sealing the piece at the same time as applying the first base coat. I usually use a poly-sponge brush, which is wonderfully easy to use. There are no brush marks and it gives very even coverage. Lightly sand when dry with 400/600 wet-and-dry sandpaper, then recoat.

Plaid Folk Art base paints have a sealer in them already.

Drying time may be shortened by using a hair dryer or placing the article in front of a fan heater. Let cool before proceeding.

You can use acrylic house paint if you are matching pieces to existing furnishings but long-term durability may be affected. If you are planning to paint an heirloom piece, it is much better to use Jo Sonya base paints, Folk Art Velvet base paints, or another reputable paint intended for folk art.

Preparation procedures for metals

New metal

Preparing metal surfaces is an area that causes people a great deal of confusion. There are two recommended methods.

Method 1, using Jo Sonya Sealer
New metal sometimes has an oily finish on it that will not accept any paint. Use a vinegar-and-water solution, in equal parts, to remove it. Using the dishwasher is also effective if the articles are small (plates, cups). Dry thoroughly, being certain to remove water from the rolled edges.

As metal is shiny you need to give it 'tooth' so the sealer can 'bite' into it. Using Jif (or any cream cleanser) and a green scouring pad, buff every surface thoroughly. There is no need to rub hard. Dry. Apply one coat of Jo Sonya All Purpose Sealer and allow to dry. Using the Jo Sonya tube colour of your choice, mix it with Jo Sonya Water-Based Sealer (1:1), and apply with a poly-sponge brush. Dry and recoat. If the object is small, you can bake it in the oven to speed up the curing process. Using the oven's lowest setting, bake the tin ware for approximately twenty minutes. Higher temperatures may melt the solder in the seams. Allow to cool before painting on the pattern. If the object is very large and won't fit into the oven, apply one coat of the colour–varnish mix and, when dry to the touch, place in the sun for a few hours. Cool and repeat. This isn't quite as effective as the oven, but it does help, especially in summer.

Method 2, using metal primer
Wash the article in a water-and-vinegar solution, as in Method 1. Dry thoroughly. Now apply a suitable metal primer, such as Haloprime by Galmet. This is a water-based non-toxic product and is very easy to use—just brush it on. After three hours apply Epoxy Rust Paint, which comes in a range of colours and is a rust inhibitor. You will need two coats, sanding lightly between each coat. Dry thoroughly. This method is suitable for pieces that will be subject to damp.

If you intend to paint the piece with a gloss colour, scuff the surface lightly with Jif or another cream cleanser to give the surface some 'tooth' for the acrylic paints to adhere to. You need only scuff the areas where the design will be. Wash with warm water to remove any gritty residue.

Old metal or tin

If the tin is in good condition follow the preparation procedures for new metal. If the metal is in poor condition, rusty, or just too big a job, e.g. a trunk or milk can, consider having it professionally treated. Some commercial establishments will powdercoat or sandblast and prime your items in a variety of colours. Rather than spending hours on preparation you can have it done for you rather inexpensively.

If you choose to treat the piece yourself you will need to kill the rust first. Use Galmet Ironize CS, which penetrates the surface and kills the rust as well as protecting the area. First remove all the flaky paint and brush the surface with a wire brush. Rinse off with water. Apply the Ironize CS and allow a reaction time of two or three hours. The article may then be overpainted with a primer such as Haloprime and, after waiting the recommended drying time, Epoxy Rust Paint.

Finishing techniques and transferring designs

Varnishing

There are many types of varnish available, but the idea behind them all is to protect your finished piece with a tough coating. There are four types of finishes you can choose from: matte—dull with no shine; satin—a soft glow resembling a hand-rubbed finish; semi-gloss—a slight shine, and gloss—a bright shine.

I normally use a brush-on polyurethane water-based varnish but the spray varnishes are very popular. If you prefer to use these follow the safety directions on the can very strictly. Remember to spray lightly, as spraying too heavily causes drips.

Before varnishing make sure that the piece is thoroughly dry, and check there are no graphite lines still visible. These can be removed with a kneadable eraser and tack cloth.

I usually apply the varnish with a poly-sponge brush but some artists prefer a 2 cm to 3 cm flat brush (¾'' to 1''). Whichever you choose, the article must be completely dry before you start or it may cause streaking. Varnishing in an extremely cold room or on a very cold day may result in cloudiness. Work in a well lit area so you can see any drips or fluff that may appear. Use light coats, waiting between for the length of time specified by the manufacturer.

Most pieces will need at least three coats; for an alcohol-resistant surface four to six coats are preferable.

Depending on personal preference you may wish to rub down the final coat with #0000 steel wool (available at hardware stores) and wax the surface with a good quality paste wax such as Busy Bee Beeswax Furniture Wax. Let dry and buff to a beautiful sheen.

Pickling

Pickling is a term originally used to describe the white residue left in wooden barrels that had held pickles. It is a lovely soft effect and looks particularly effective on pine.

The same effect can be produced in very little time using modern techniques. Mix about 4 parts of clear glazing medium with 1 part of a pale tube paint—opal, white or even very pale pink or blue. Using a poly-sponge brush and working with the grain, brush on the mixture. As with most acrylics this dries very quickly, so if you are wanting more working time, especially in hot weather, add 1 part Retarder to the mixture. Quickly wipe off the residue, making sure the finish is smooth, carefully removing excess paint where two brush strokes overlap. If you feel the pickle isn't dark enough do a second coat when the first has dried. It is better to be cautious and start off too pale then be heavy-handed and end up too dark.

Lightly sand with 400/600 wet-and-dry sandpaper before painting on the design.

Staining

Light coloured woods may be stained before painting. Mix 3 parts Jo Sonya Clear Glaze Medium with 1 part Retarder plus 1 part colour of your choice. Using a poly-sponge brush apply the stain then wipe off the cloth, making sure to wipe with the grain. The Retarder added to the mixture means the stain stays open longer and you can work more effectively with it.

You can use any colour to stain the wood—be adventurous. If you are wanting to simulate natural wood colours then try combinations of the earth colours—Raw Umber and Brown Earth in Jo Sonya colours (1:1) give a lovely walnut colour. To add a slight green tone use a little Pine Green.

If you want only a very light stain, seal the wood with Jo Sonya Clear Glazing Medium before applying the stain.

Remember that end grain is more porous and will stain a darker colour, so should be sealed first with a coat of Clear Glazing Medium.

Crackling

(illustrated on page 14)

Crackle medium creates a wonderful aged, weathered appearance. The technique takes a little getting used to, so it is a good idea to practice on scrap pieces of wood before you attempt a finished article. Most manufacturers recommend you use their brand of Crackle Medium only with their brand of paint.

If you are using Jo Sonya Crackle Medium, apply three or four heavy coats of base paint first. Do not speed dry, as the paint must not cure. The thicker and fresher the paint, the deeper the crackle. When the background paint is touch dry, apply the pattern outline and paint it. Do not speed dry with the hair dryer, and do not leave overnight before crackling, but apply the crackle medium immediately the decoration is touch dry.

Using a large soft brush, apply one thick coat. Some artists pour it on and spread it out with their fingers. For smaller cracks, allow the medium to dry naturally, but for deeper crinkly cracks use the hair dryer.

When the piece is thoroughly dry, sand the surface gently using 400/600 wet-and-dry sandpaper. You may wish to finish by antiquing the piece as well.

Deco Art Weathered Wood

This is a different technique using Americana products. Basecoat the article with Americana acrylic paint and let it dry naturally. Brush on one even coat of Weathered Wood and allow to dry for between 20 and 60 minutes. Now apply a top coat of a contrasting colour and watch the large cracks appear. When the top coat dries you can paint or antique over it.

Flyspecking

(illustrated on page 14)

Flyspecking is also called spattering or flecking. It is used to soften the appearance of an article by putting tiny specks of paint all over the surface. It is also fun to do—kids love it. I use an old toothbrush, the rattier the better. The consistency of the paint is very important, as it affects the size of the specks. Add water until the paint is the consistency of ink. Dip the toothbrush into this mix and, holding the bristles up, pull your fingernail or a ruler over the bristles *towards* you. (You will be covered in spots if you go the other way.) The best results are achieved holding the toothbrush about 30 cm (12'') away from the article. Spread plenty of newspaper around, as the specks fly everywhere, and do a few trial runs on paper first, adjusting the distance until you are happy with the size of the specks. Any extra large ones can be removed with a cotton bud.

Until you become comfortable with this technique you may want to protect the finished article with one coat of varnish before you flyspeck. If you don't like the results you can quickly wipe off the flyspecking with a damp cloth.

Antiquing

(illustrated on page 14)

Antiquing gives the surface of a finished piece an aged appearance, imparting the same depth of tone to all the colours. There are two methods of doing this.

Method 1, oil-based

This method, which uses oil-based products, should be done in a well ventilated area. Wear disposable gloves and when the antiquing is finished, throw the gloves and all the rags and papers you may have used in the rubbish bin. Wet them all thoroughly first, as a few cases of spontaneous combustion have been reported.

Even though this method usually removes graphite lines, it is a good idea to clean them off anyway.

You will need a supply of patina oil, made of 1 part refined linseed oil and 4 parts gum or natural turpentine. Mix this together and keep it in a screw-top jar—it will last for years.

You will also need oil paints, either Winsor and Newton, or Rowney. I usually use Burnt Umber, but consider also Raw Umber, Burnt Sienna, Black, Indigo Blue, Prussian Blue and Raw Sienna.

Squares of lint-free cotton cloth, and plenty of them.

A few hints before you start:

1. Work one surface at a time. Oil paints take much longer to dry than acrylics and it's woefully easy to leave finger marks on a surface which has been newly antiqued.
2. Any 'slop-overs' that may happen, e.g. on a side you haven't antiqued yet, underneath or inside, should be wiped off quickly.
3. If you don't like the colour or the way it looks you can remove nearly all of it by moistening a clean cloth with the patina oil mix and wiping it off. Don't leave it to dry before you decide you don't like it—it must be removed fairly quickly.

Procedure:

Moisten a small area of a clean cotton square with the patina oil mix. Wipe this over the area to be antiqued, making sure the entire surface has been covered, and leaving no puddles or drips. Now, on the same area of cloth that you applied the patina with, pick up a small amount of tube *oil* paint. Stroke this onto the surface with smooth even strokes until the area has been covered. Take a clean cotton rag and smooth out the antiquing to the desired depth. It looks more effective when the edges are darker than the middle. Make sure the antiquing gets into all the joins and crevices.

If you would like certain areas lighter, remove the antiquing with a cotton bud dipped in the patina oil mix.

Sponging using Americana colours—Rookwood Red, Dusty Rose and Buttermilk on a light grey background

Flyspecking using Americana Rookwood Red over a light grey background

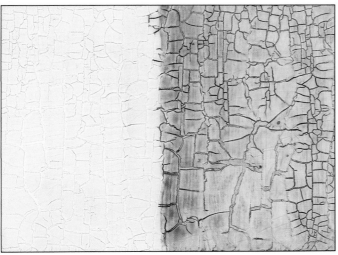

Crackling and antiquing using four good coats of Titanium White as a base over the whole surface, each coat being allowed to dry naturally before the next coat was applied. Crackling Medium was then applied over the whole area, and allowed to dry

The right side was then wiped over with a 1:1 mixture of Jo Sonya Retarder and Antiquing Medium and Jo Sonya Brown Earth tube paint to give an aged or antiqued effect.

Smooth out the area afterwards. Try and bring contrast into the finish. Spray seal with Crystal Clear Spray Sealer. Do not use water-based varnishes over the oil-based antiquing.

Method 2, water-based

Because this method uses water-based products there is no problem with smell. You will need:

 Jo Sonya Retarder and Antiquing Medium
 Jo Sonya Clear Glazing Medium
 Jo Sonya tube paints—any colours or mixture of colours can be used, but preferably an earth colour, e.g. Brown Earth
 Rags
 Sponge brush
 Large mop brush

Procedure:

Allow the finished painted article to dry thoroughly. Give all the surfaces to be antiqued one coat of Clear Glazing Medium and let dry overnight.

Mix your chosen colour with the Retarder and Antiquing Medium to the desired depth of colour. Try mixing 1:1 for the darker colours, e.g. 1 part Retarder and Antiquing Medium to 1 part Brown Earth. Test a small area of the work to see if the colour's transparency is correct. If it isn't dark enough add more tube paint.

Using the poly-sponge brush apply the paint and antiquing mix evenly over the surface. Start wiping back immediately using a clean lint-free cloth. Areas to be highlighted can be wiped out with a water-moistened cotton bud and the edges softened with a large mop brush.

Just as the Antiquing and Retarder Medium slows the drying time of the paints and mediums used with, or under it, it will also affect any product used over it. To minimise any problems allow 7 to 10 days for the surface to dry out before applying Jo Sonya Polyurethane Water-Based Satin Varnish. (You can gently speed the drying process with a hair dryer.)

Sponging

Sponging is a very simple and effective faux finish made using a natural sea sponge (the kind that is used to apply make up).

Seal the wood first with Jo Sonya All Purpose Sealer. You may basecoat the surface with a contrasting colour to the one you intend to sponge with, or leave the natural colour of the wood. Let dry.

Wet the sea sponge and squeeze out the excess water. Place two separate puddles of paint on your palette, one that contrasts with the basecoat and white.

Dab the moistened sponge onto the paint puddle and dance it up and down on another area of the palette to remove excess paint. Now bounce the sponge onto the surface of your piece. When you have sponged on the colour load the sponge with white in the same manner and sponge that on. You will have tints of the first colour mixed in with the white. Keep the sponging very 'open'—that is, try not to muddy the colours by oversponging. With practice you will be able to add another colour to the first colour and white.

Tracing a design

The designs in this book can be traced by the following method. (They can also be adapted to fit other pieces.) Place the item to be decorated on a sheet of greaseproof paper and trace around its edges to give you its perimeter. Divide the area in half both widthways and lengthways by folding the greaseproof paper. You now have the centre of the design. You can lay the greaseproof paper over the designs in the book, moving it around until the design fits into the confines of your piece. Trace the design from the book using a sharp pencil. Tape the design over the prepared surface, using masking tape, and slip a sheet of graphite or transfer paper in between them. Use light graphite paper on a dark background and vice versa. Make sure the graphite side is against the surface to be painted. Using light pressure to avoid denting the surface, transfer only those lines that are essential to the design. When you have finished, check to make sure there are no heavy graphite lines. If there are, rub them back with a kneadable eraser. You are now ready to paint.

Transferring a pattern using chalk

Once the design has been traced onto the greaseproof paper, turn the paper over and rub the back of it with blackboard chalk. Use a colour appropriate to the background of your piece. Shake the greaseproof paper to get rid of the excess chalk dust and place it chalk side down on the surface of your piece. Gently transfer the design.

The only pitfall using this method is that the chalk is easily erased if you accidentally drop water onto it, but for small simple designs, it's excellent. Conversely, it's easy to fix a mistake.

Brush stroke worksheet

The first four rows were painted with the No. 5 round brush, the last two rows with the liner brush.

To get the best out of your worksheet photocopy it so you won't get paint on your book. Place the photocopy inside a plastic sleeve and lay a square of greaseproof paper over it, taping it securely on either side, so you can see the strokes clearly through the greaseproof paper. Check the What went wrong sections if your strokes don't look right.

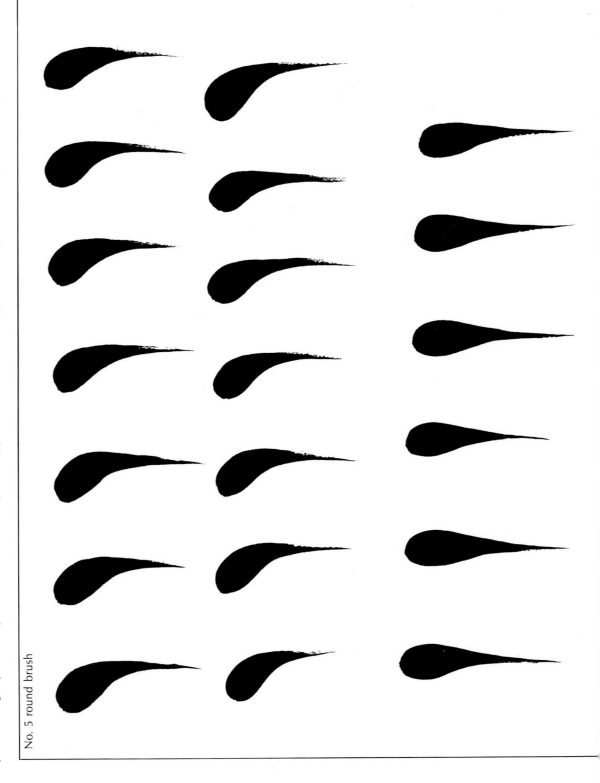

No. 5 round brush

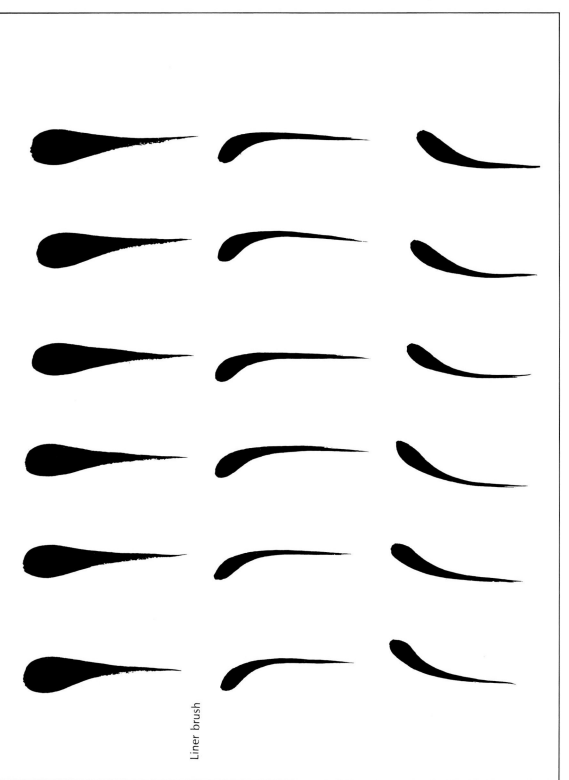

Liner brush

Here is a checklist:

1. Make sure the brush is dressed correctly. See page 18.
2. Check the position of the brush. You should be holding it upright, not on the same angle as a pen.
3. Rest lightly on your little finger and the outside of your palm.
4. Follow the direction listed for each stroke.

Stroke formation—round brush

Hand and body position

The bench or table you are working at should be low enough for your shoulders to remain naturally low. If you find they are hunched up, move to a lower table or sit on a higher stool.

Hold the brush perpendicular to the painting surface. Keep the weight of your hand balanced on your little finger and the side on the palm. It may feel strange at first but persevere, as this position gives excellent control. Don't hold the brush as you would a pen or pencil—it should be more vertical. In the beginning you will need to keep checking on the position of the brush, but after a while it becomes second nature.

Loading the brush

Put out a ten-cent sized puddle of paint. The brands of paint mentioned in this book are all the correct consistency for beautiful strokework. If in doubt, remember the paint should be flowing, like thickened cream. If for some reason it isn't you will need to add water or medium to bring it to the correct consistency.

Jo Sonya Flow Medium, an additive to even out the texture of tube paints, helps the flow of paint, especially with line work.

Dressing the brush

Push the tip of the brush into the puddle and pull out a small amount of paint. Work the paint into the bristles, flipping from the back to the front of the brush, pushing the paint into the hairs. This is called 'dressing the brush' and ensures the paint is evenly distributed throughout the hairs. Do not

leave globs of paint clinging to the sides of the brush. Dressing the brush correctly is very important for beautiful strokes, so spend the extra time making sure the paint is worked through the hairs.

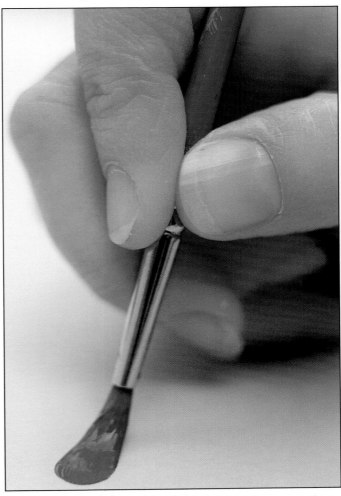

A well loaded and dressed brush beginning a comma stroke; this picture gives a good view of the hand position

Comma stroke

With the brush correctly dressed and held in the correct vertical position, press the tip of the brush down onto your practice paper and pause a moment to let the hairs fan out. Gradually pull the brush towards you, releasing pressure and lifting simultaneously. Slow down near the middle of the stroke to allow the hairs to come back into alignment and so avoid scraggy tails.

Your comma stroke should look like mine in the illustration. If it doesn't, check what went wrong and try again. Remember—persevere.

The comma stroke is the most commonly used stroke. In Irish folk art it is the symbol for the soul. It may be easier to paint knowing that it represents something.

What went wrong

1. Body of comma is too long. Lift the brush up after the head of comma is formed.

2. Brush was laid down to the ferrule—too far. Stay up on the tip of the brush, using pressure to fan out the hairs, rather than laying the brush down.

3. Stroke is too curved.

4. This is a 'walking stick' stroke. The brush was laid down to the ferrule and then the tail flipped under. Slow down and use pressure on the hairs rather than laying the brush down.

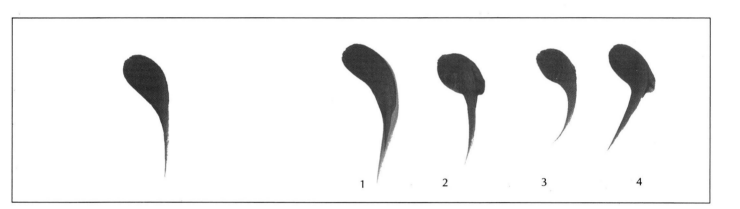

Daisy stroke

The brush must leave the palette with the hairs rounded. Press down on the paper to fan out the hairs, as for the comma stroke; now, release the pressure and pull the brush towards you, at the same time rolling your thumb forward and twisting the brush half a turn. The brush should roll between your finger and thumb. Don't tuck your thumb behind your index finger.

What went wrong

1. Pressure was released too quickly. It should change gradually.

2. The thumb was tucked behind the index finger so that when forced it jumped, and control was lost.

3. This stroke was pulled before the hairs had a chance to fan out. Remember—pause.

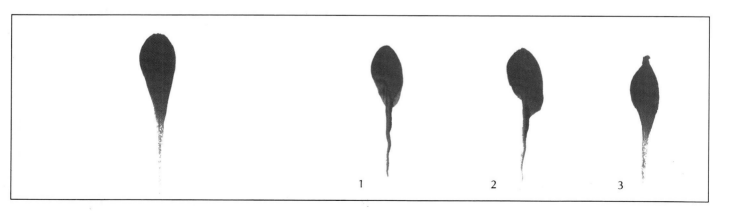

S stroke

The brush must leave the palette with the hairs flattened. Stroke the bristles over the palette until they flatten out. You are really making a flat brush with a chisel edge. Starting on the chisel, move to the right in this case (but you can go either way), applying pressure as you move down. Slow down and level off, keeping on the chisel (or flattened point).

What went wrong

1. The brush left the palette rounded, not flattened.

2. Slow down at the bottom and allow hairs to flatten.

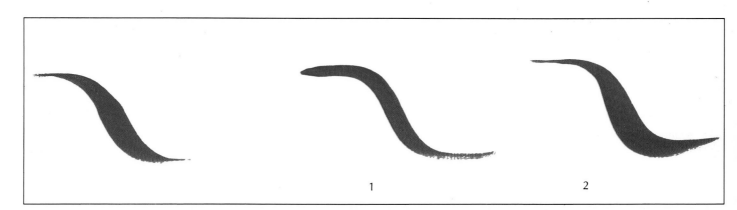

C stroke

The brush leaves the palette with the hairs flattened (a chisel edge). Move to the left, apply pressure, slow down, and chisel to the right. It may be easier for left-handed painters to reverse these instructions.

What went wrong

1. Too much pressure at the beginning of the stroke.

2. Concentrate on making both ends the same.

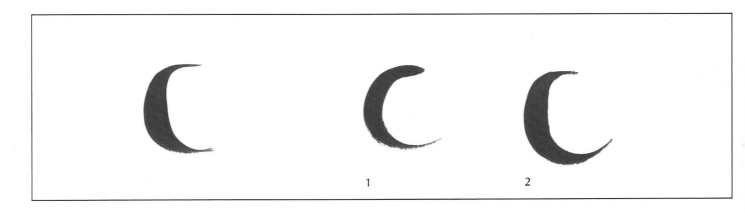

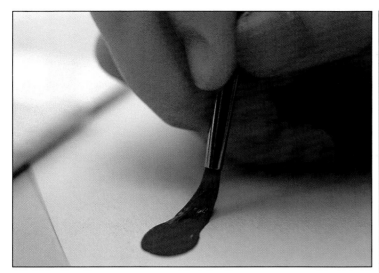

The beginning of the comma has been formed—now you must slow down to allow the hairs to come back into alignment, at the same time lifting and pulling towards you

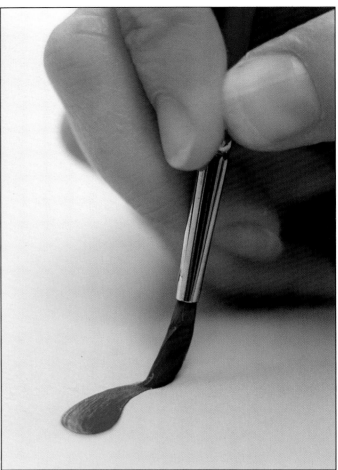

The end or 'tail' of the comma stroke

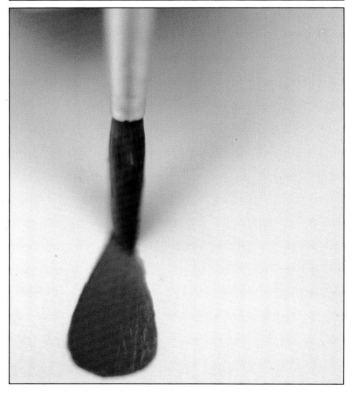

Halfway through the daisy stroke

Stroke formation—liner brush

Comma stroke

This comma stroke was painted with paint straight from the puddle, the paint really being pushed into the hairs.

What went wrong

1. Too much water or medium for a comma stroke, but perfect for cross hatching or line work. No bulk to the stroke.

2. Hairs were laid down to the ferrule. Keep up on the tip.

Tear drops (sit downs)

Leave the palette with a point on the brush, and keep on the tip. (It helps if there is plenty of paint in the middle section of the brush.) Slow down and apply pressure then lift and straighten up.

What went wrong

1. Hairs were pushed back up when lifting off. Slow down.

2. Remember to come to a complete stop before lifting off.

S stroke

The principle is the same as for the S stroke with the round brush, but start off on the tip and apply increased pressure for increased thickness. Slow down and lift off to finish. Top and bottom of the stroke should look the same.

What went wrong

1. Maintain even pressure so that top and bottom match.

2. The brush left the palette rounded, so the beginning is too heavy. Stay up on the tip.

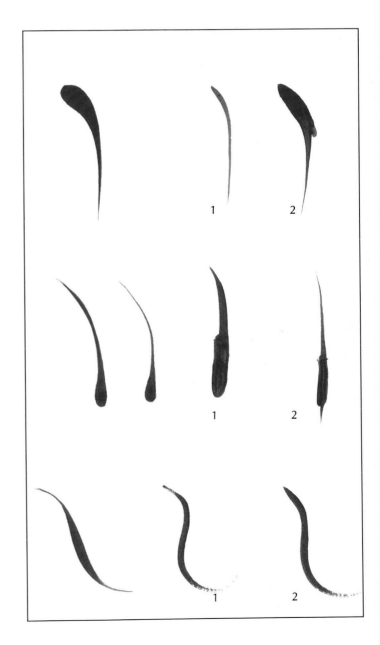

Horizontal stroke

Leave the palette with a point on the brush. Keep on the tip, then apply pressure until the middle of the stroke, slowly decreasing from the middle until the end. Remember, by applying pressure you increase the width of the stroke.

What went wrong

1. Too fast at the end. Slow down.

Cross hatching

The paint must be thinned with water or medium for successful cross hatching. Fill the brush up to the ferrule. Stay up on the tip and keep the brush vertical.

What went wrong

1. Paint is too thick.

2. Uneven pressure and paint is too thick.

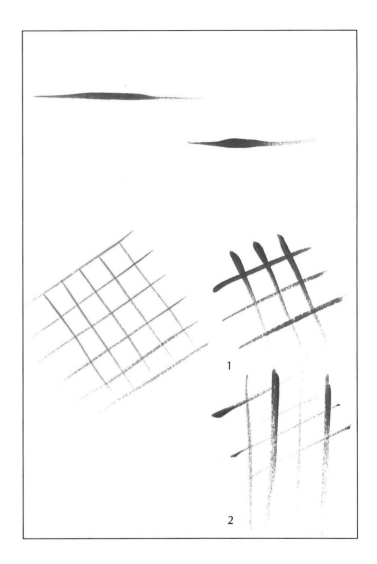

Swirls and tendrils

Use thinned paint and keep your hand and arm *off* the table. Move from the shoulder.

What went wrong

1. Uneven pressure from poor hand and arm position.

Special brush techniques

Side loading (round brush)

Now you have practised the beginning strokes you should feel comfortable with your brush and know what it can and can't do. Side loading is a little tricky in the beginning but is well worth perservering with. Here we go.

Dress a No. 5 brush with a dark colour, say Burgundy. This will give good contrast with the white side load. To side load, push the brush horizontally into the puddle of paint and pull it out towards you. It helps to have a strip of paint rather than a puddle, and to work along it. See diagram 1. You should have white paint on only one side of the brush, as in the diagram.

Try not to drag the brush on the palette as you pull it towards you, as this will wipe off some of the paint. Look at the brush and make sure the white is only on one side of it. If it isn't you will have to wash the brush and start again.

Now, holding the white to the top of the page (not to the roof; see diagram 2), practise pulling comma strokes. The strokes should have the white down the right or left side, depending on which way you pulled the comma. See diagram 3.

Both paints must be of the same consistency or one will slide off the other. If this occurs put out fresh paint.

Rolling the brush to the top or the bottom results in tipping (see page 27). Aim for a nice ridge down one side of the stroke.

1.

Push in, then pull out and up towards you

Side load should be clearly visible down half the bristles

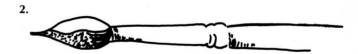

2.

Hold the side load to the top of the page

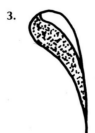

3.

Comma stroke should have white clearly visible down one side

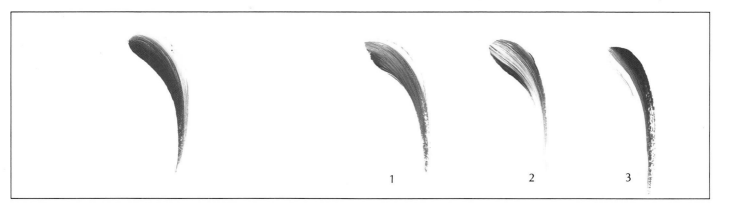

1 2 3

What went wrong

1. Brush was rolled under so blending occurred; the white was lost halfway down.

2. The white was held to the roof, not to the top of the page.

3. The white was held towards the bottom of the page, not to the top.

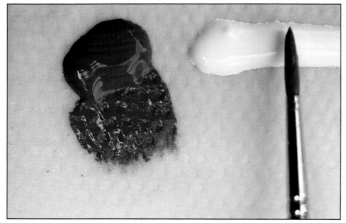

Paint laid out in a thin strip ready for side loading

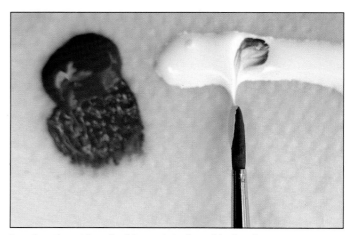

Leaving the strip of white paint after side loading

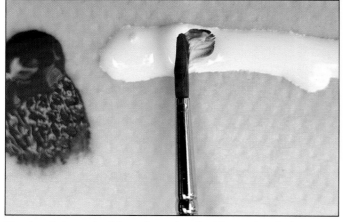

The brush is pushed into the strip of white and pulled out towards you

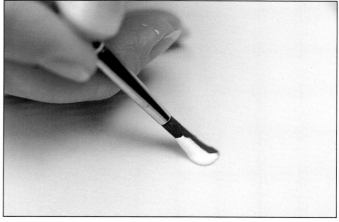

The white is held to the top of the page, the correct position for side loading

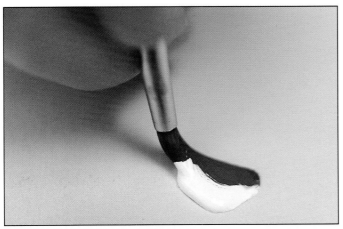

The side loaded comma half completed

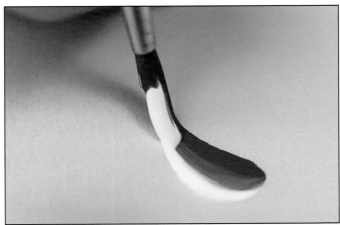

The 'tail' or end of the side loaded comma being completed

Pull-in

The pull-in is harder again than side loading but is my favourite style. There are a few things to remember:
1. Aim for a thick ridge of paint around the edge of the petals.
2. Wipe off all excess paint on a rag. Try to keep out of the water jar unless you find the brush dragging across your work.
3. Spread the hairs on the brush so they fan out. If you keep these things in mind you shouldn't have too many problems.

Squeeze out a strip of white on the palette, plus a good contrast colour, say Burgundy. Using the No. 3 round brush and the side loading technique (see page 24), pick up a load of white paint and lay it down on the paper following the shape of the petals. Wipe off the excess paint and wipe in the burgundy, making sure the hairs on the brush fan out (see diagram 1). Push the fanned out hairs under the ridge of paint and pull the colour down to the middle of the flower. Wipe off excess paint. Wipe in the burgundy, flatten out the hairs and repeat.

Make sure the strokes come down to the middle and follow the shape of the petal (see diagram 2). With this technique you must make certain to paint the petals at the back first so the ones in the front will cover the raggy ends. I have included numbers on the patterns where this technique is used to prevent confusion.

1. Flatten the hairs on the brush by wiping gently on the palette

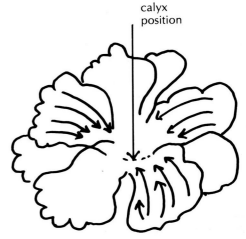

calyx position

2. Pull the strokes from the edge into the middle of where the calyx would be if it were visible

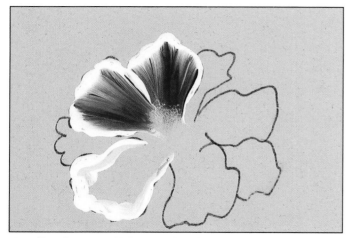

A pull-in flower partially completed

Tipping or wiping

The tipping technique is the same for round and liner brushes. Load the brush in the main colour, e.g. for a leaf use green, then wipe the tip of the brush in a second colour, say, white. Paint the stroke. You will have green streaked with white. Tip the brush in clean white each time you reload, or you will be making pale green on your palette by going over and over into the same area.

Tipping the brush with the white held to the top

Thinning

Where an instruction calls for thinned paint, you need to add water or medium to reduce the consistency of the paint. This will enable long flowing strokes to be painted. I recommend you try Jo Sonya's Flow Medium. If an extremely thin application is required, water can also be added.

Dots

Use fresh paint and the *handle* of the brush. Dip into the middle of the puddle and set down onto the paper. Dots will decrease in size each time you put the handle to the paper. Five dots in a circle with a contrasting dot in the middle make a very simple flower.

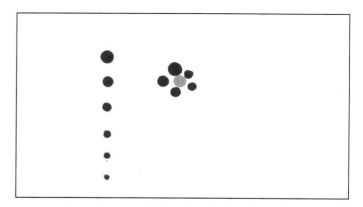

PROJECTS

Easy wooden rocking horse

Pattern on page 62

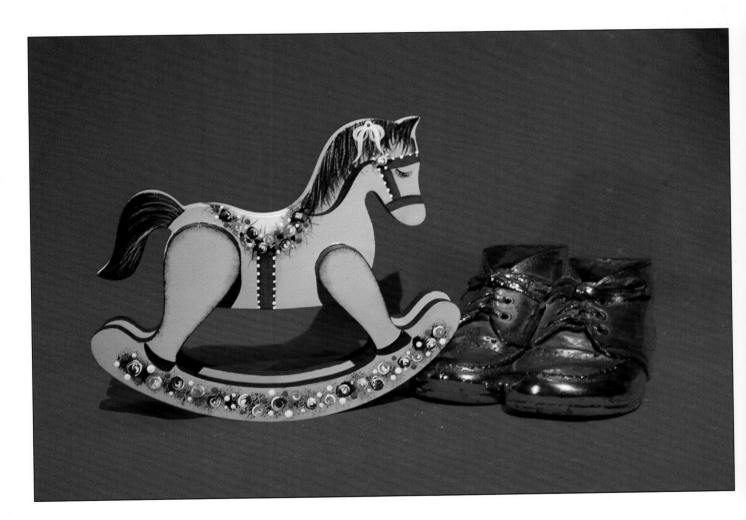

This rocking horse is so easy you will be making them by the dozen. It also gives you lots of practice with liner brush techniques.

The horse is available from Timber Turn Woodturners in South Australia (see suppliers' list on page 79).

Palette (Americana colours)
Ebony Black
Dove Grey
Light Avocado
Plantation Pine (transparent)
White Wash
Cranberry Wine
Antique Gold
Mauve
toothpick
sponge
graphite paper

Method
Sand all the cut edges well. Basecoat the whole horse in Dove Grey. Recoat, dry and sand lightly. Mix 2 parts Dove Grey with 1 part Ebony Black. Using a small flat brush basecoat all the inside edges of the rockers in this mix, the tail and around the legs. Flick the brush gently onto the front of the leg to softly shade the edges (see diagram). Paint in hooves.

Basecoat the saddle in White Wash. Very lightly sponge the area underneath the stick roses with Plantation Pine, then Light Avocado.

Basecoat the girth, reins and bridle in Cranberry Wine—you may need two coats.

Using Dove Grey and the liner brush, pull out lots of hairs in the tail and mane. Repeat the process using Ebony Black. Add just a few hairs in White Wash.

Using Ebony Black paint in the eyelashes and the line across the top of the hooves. The bow in the mane and the watery cross hatching on the girth and bridle are in White Wash.

The stick roses trimming the saddle and rockers are very easy.

The paint must be fresh. Be generous with the blobs (see instruction diagram). Place a half circle of Cranberry Wine fairly thickly on the horse, and next to it place a half circle of White Wash. Take a toothpick and gently stir them together, trying not to touch the bottom. Too much stirring will blend the colours—usually three times around is enough.

The roses do take a while to dry because they are so thick. You can speed dry with a hair dryer, or have a cup of tea.

Pull tiny wisps of Plantation Green out from between the roses. Add dots of Mauve, then White Wash. To be on the safe side let dry for two or three days before varnishing with three coats of polyurethane water-based varnish.

Wooden flower basket doorstop

Pattern on page 64

My mother had a lovely vase in this shape when I was young. She would fill it with pretty blue hydrangeas from the garden.

I have included a full size pattern for this design so you can easily trace the shape onto 6 mm craftwood and cut it out. A jigsaw makes life easy here! Sand lightly, being very careful with the cut edges.

Palette (Jo Sonya colours)
Pine Green
Carbon Black
Moss Green
Storm Blue
French Blue
Ultramarine Blue
Colony Blue
Sapphire
Retarder Medium

Basket For the basket I used a little paint roller to cover the entire area with Warm White and Retarder. Using a small sponge, bring in some French Blue from the edges, keeping the area in the middle of the basket lighter than the edges. With the sponge again, bring some Storm Blue up the left side and under the lowest hydrangea, fading off as you near the top of the basket. Also darken along the bottom edge. Try and do this subtly so the colours blend softly. The retarder will keep the paint 'open' so you have more time to play with it. If you find it is too blue just add a dab of White and blend it gently. Let the paint dry. Apply the basket lines very lightly with graphite paper. Use a liner brush and Storm Blue paint for the dark, vertical lines, Warm White for the lighter curved S lines at the base and on the handle. The thick elongated horizontal shadow lines are painted in thinned Storm Blue using a No. 5 round brush. The cut edges of the basket are painted in French Blue.

Leaves Using a mixture of Pine Green with a touch of Carbon Black, base in the leaves with a No. 5 round brush. While they are wet pick up a little Moss Green on the same brush and add some variation to them. A few could be lighter than the rest. Using the liner brush with Pine Green and Black, edge all the leaves and paint in the veins.

Hydrangeas The hydrangeas are easy and lots of fun to paint. Work only one flower at a time and try to keep the

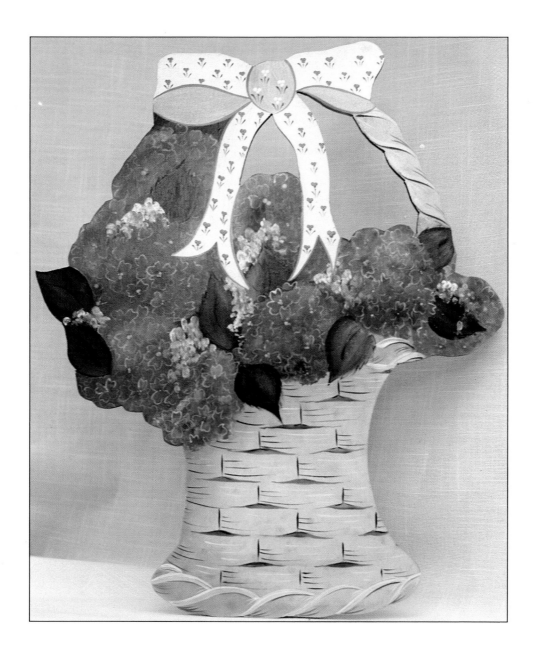

flowers separate. Keep lighter pinks and blues to the top of the flowers and darker blues and burgundies at the bottom. Retard the area and pick up a little Storm Blue and dab on the bottom area. Pick up some French Blue, Colony Blue or Ultramarine Blue and Sapphire and dab on around the Storm Blue. Now pick up a little Plum Pink or Burgundy and dab that on to the flower area. You are trying to create very washy, informal areas. Use various combinations of these colours to create lovely soft balls of irregular colours. While the area is still wet, use Warm White on the liner brush to outline a few of the petals. The retarder should make the white 'bleed' and soften the shape of the petals. If it doesn't, add a little more retarder to the area. Paint only one hydrangea at a time. Dots of Yellow Oxide can be

placed in the centres when all the flowers are completed and dry. The cut edges are painted in Storm Blue.

Filler flowers Load a No. 5 round brush with Retarder, pick up Warm White and dab filler flowers here and there. You can also use a little Plum Pink if you like.

Bow Basecoat in Warm White. Dots and linerwork are in Plum Pink. The leaves and stems are in Pine Green. The inner side of the bow and the knot are a mix of Plum Pink and White, as are the cut edges of the bow.

Finish with three coats of polyurethane water-based varnish.

Ring of roses wooden box

Pattern on page 66

Available from Boyle Industries in Victoria.

Palette (Folk Art colours)
Poppy Seed
Spice Pink
Thicket
Robin's Egg
Chocolate Cherry
Wicker White
Milkshake

Basecoat the box in Poppy Seed. Lightly sand and recoat.

Trace around the central oval on the top and basecoat in Milkshake, making sure you don't have a ridge around the oval. Recoat. Sponge Thicket and Robin's Egg around the oval and on the sides, about 3.5 cm up from the bottom. Apply pattern, omitting the squiggles. Now load a No. 5 round brush in Chocolate Cherry, sideload in Wicker White, and complete the dark roses. They should all be very casual, so don't strive to keep exactly to the pattern. It's a good idea to paint the roses on the lid first, then go on to the sides,

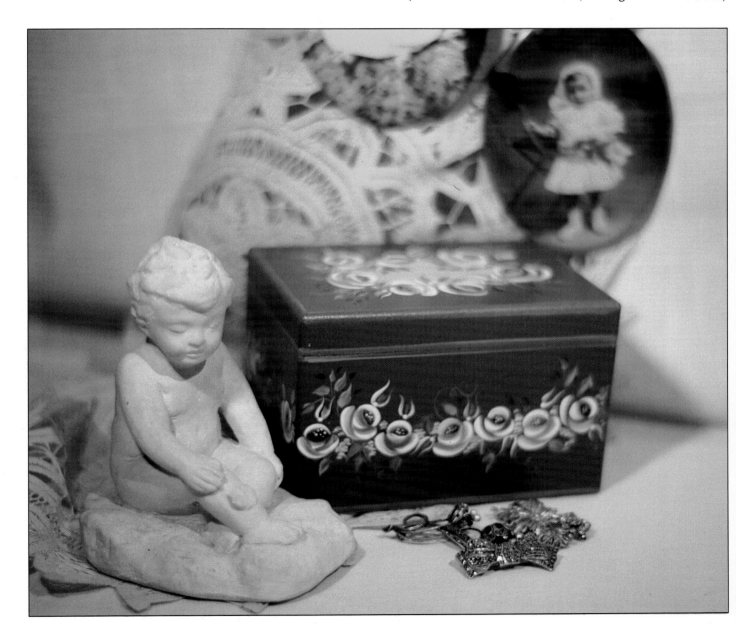

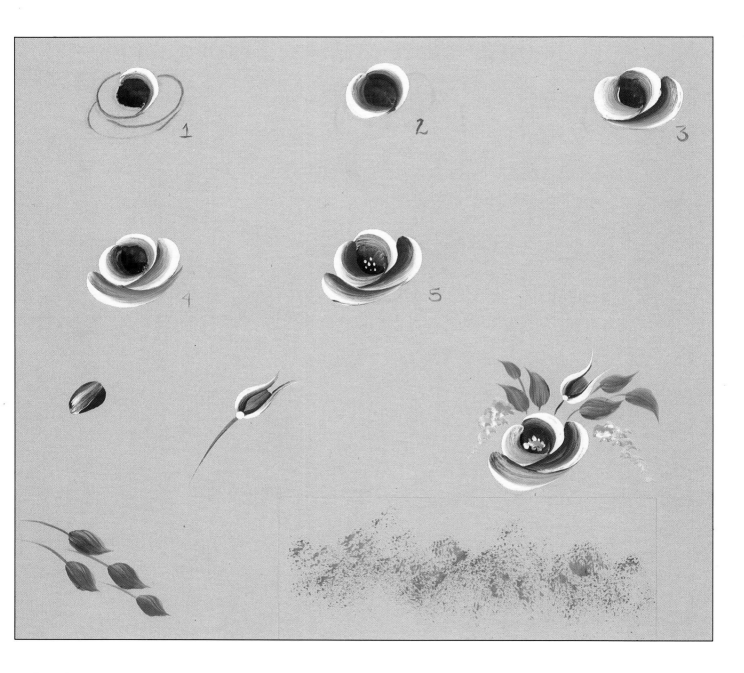

as these little roses take a while to dry. You can speed dry with a hair dryer if you're really in a hurry.

For the centres of the roses, dabble Thicket in the middle of all of them. Allow to dry. Now paint in the Spice Pink roses. Dry.

For the leaves, load a No. 3 round brush in Thicket, wipe in Robin's Egg and casually place these little leaves wherever you feel there is a gap. Paint some of the tiny leaves in Chocolate Cherry. For the rosebuds, load the No. 3 brush in Chocolate Cherry and wipe in White. The body of the rosebud is just a blob. Clean brush, load in Thicket and wipe in White (sideloading if you like) and place outside sepals on the roses.

Use thinned Robin's Egg for the squiggles and Wicker White for the dots. The filler flowers are Harvest Gold and White.

Remove graphite lines with a kneadable eraser. Finish with three coats of polyurethane water-based varnish.

Three-heart wooden hanger

Pattern on page 63

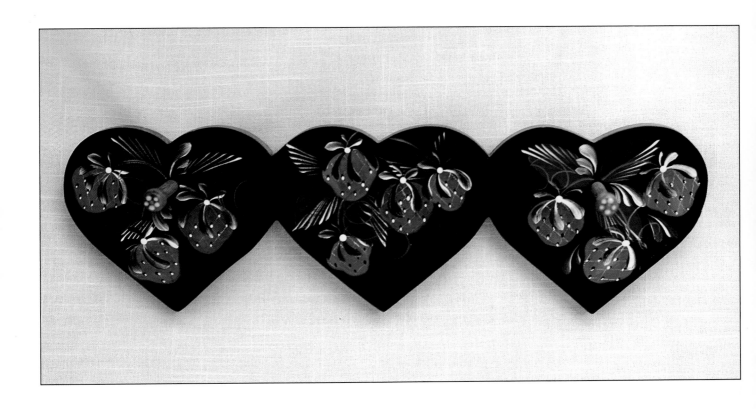

This attractive hanger comes precut from Boyle Industries in Victoria.

Palette (Jo Sonya colours)
4 parts Pine Green ⎱ basecoat
1 part Carbon Black ⎰ mix
Yellow Oxide
Warm White
Napthol Red Light
Napthol Crimson
Rich Gold
No. 5 round brush
liner brush
flow medium
graphite paper

Using the basecoat mix, paint the hanger with at least two coats. Dry and sand lightly.

Make some more basecoat mix and lighten half with enough white to provide a good contrast with the background colour. Block in the leaves using shape-following strokes in the lighter mix. Load a No. 5 brush in the Green and Black dark mix, wipe in White and flatten the brush by pressing it gently on the palette. Now turn the bristles to the knife edge and pull the knife strokes on the side of each leaf. You can use a liner brush if you prefer.

Base in the strawberries with Yellow Oxide (do only two at a time as you need this paint wet), wipe the brush and wipe in either Napthol Red Light or Napthol Crimson. For a strawberry appearing behind another use Napthol Crimson because this is a darker red than Napthol Red Light, which is better for berries that sit in the front. You can paint them all in the same red if you like, but the two different colours look good. Wipe the red down either side of the berry and around the bottom, roughly blending the yellow and red colours together. Leave the centre area yellow with only slight blending for a nice warm highlight. If for some reason the whole area ends up red, introduce more yellow to the middle area only.

Wipe off all colour from the brush and pull out a little White from the stack. Fan the brush hairs out, and tip in the pulled out area of paint, which should be fairly dry.

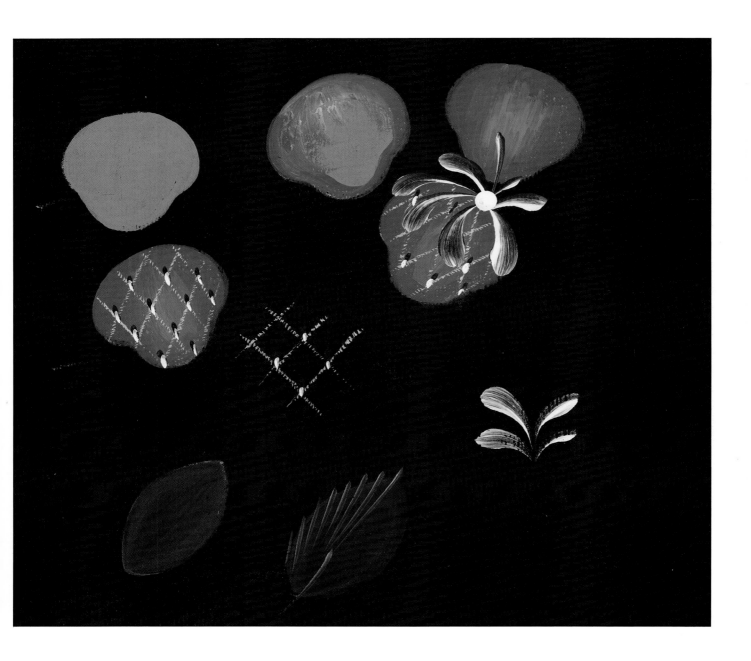

Make a trellis pattern on each berry with just the last few hairs on the brush. Using the liner brush, place a little seed shadow of the Green and Black mix in the bottom of each diamond shape. With Warm White drop in a little seed at the bottom and to the right of the seed shadow.

Load a No. 5 round brush with the Black and Green mix, wipe in Warm White, and pull comma strokes across the top of each berry to represent the hull, adding any extra commas you feel may be needed. Load the liner brush in the Black and Green mix, wipe in White and paint in the stems. Thin down the paint left on the liner brush with medium or water and paint the squiggles. Place a dot of Warm White where the stems meet the hulls. Sponge around the outside edge of the hanger with Rich Gold.

Paint the pegs with Rich Gold and dot a flower on each rounded end in Warm White with a Yellow Oxide centre.

Finish with three coats of polyurethane water-based varnish.

Terracotta pansy pot

Pattern on page 68

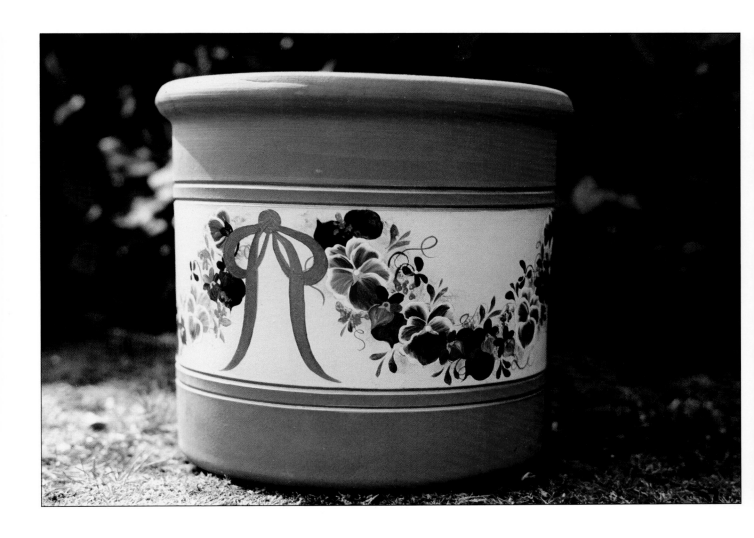

This cylindrical terracotta pot is available from Northcote Pottery (03) 480 4799. Similar pots should be available from good suppliers in most areas.

Palette (Americana colours)
Napthol Red
Ultra Blue Deep
Cranberry Wine
Venetian Gold
Antique Gold
Sand
Calico Red
Light Avocado

Plantation Pine
Ebony Black
White Wash
graphite paper

Reread the instructions on the pull-in method (page 26) before you start this project.

Basecoat the centre panel of the pot in Sand. Dry and recoat. Sponge the area where the pattern will be with Plantation Pine. Dry. Apply pattern with graphite paper.

Basecoat half the leaves with Plantation Pine mixed with a touch of Ebony Black (they will need two coats). Basecoat the remaining leaves with Light Avocado and Plantation Pine.

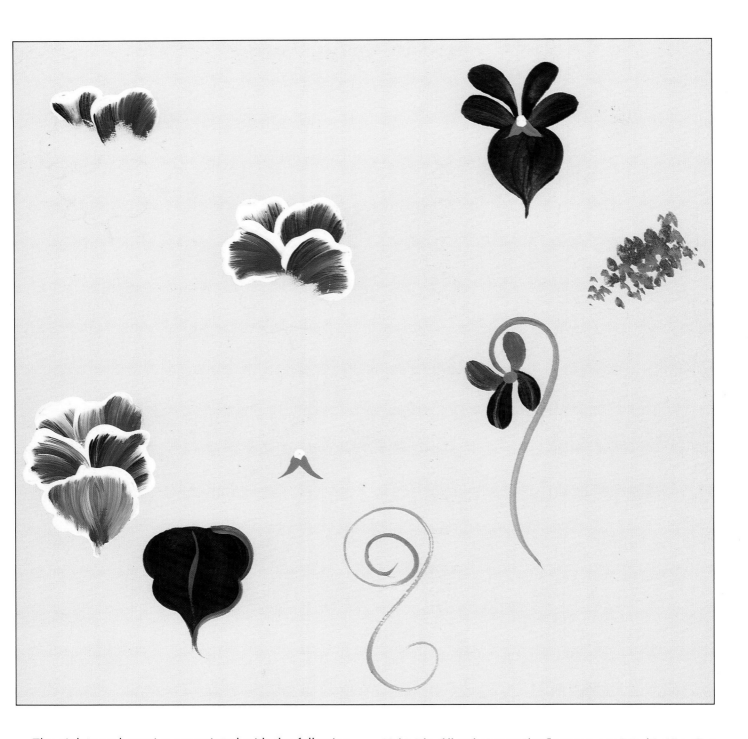

The violets and pansies are painted with the following 1:1 mixes:

Napthol Red and Ultra Blue Deep
Cranberry Wine and Ultra Blue Deep
Calico Red and Ultra Blue Deep

Adding a little White to some of these mixes is a nice touch.

Remember to start with the back petals of the Pansy and work forward. The little comma strokes above the beards on the pansies and violets are made in Antique Gold. Dots on the pansies are White Wash and the violets Napthol Red Light. The fillers between the flowers are painted in Venetian Gold.

Place squiggles and commas in Light Avocado wherever you feel they are needed.

Finish with two coats of polyurethane water-based varnish, used only on the painted area.

Note: Please remember this pot should be used as a decorative outer container only.

Oval wooden tine

Pattern on page 69

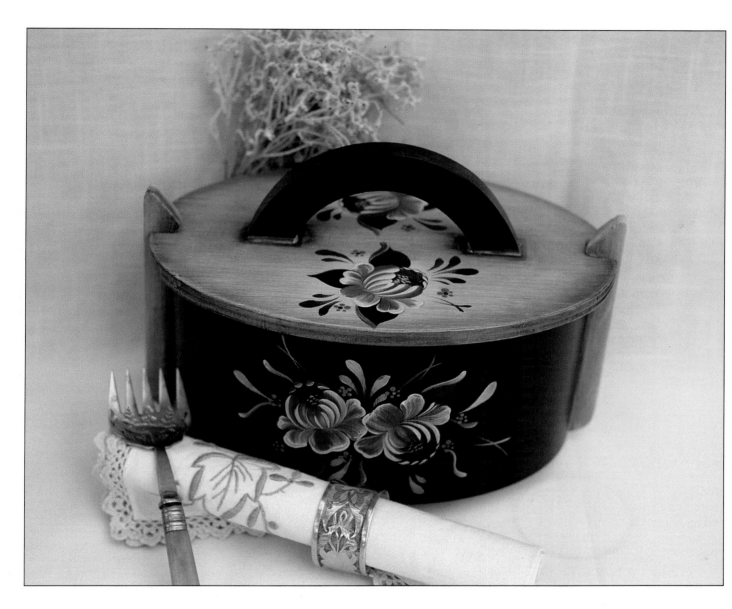

This small wooden oval tine 'comes from Timber Turn Woodturners in South Australia. The pattern is a very simple design and could be adapted to fit almost anything.

Palette (Jo Sonya colours)
Pine Green and Carbon Black (mixed 4:1)
Warm White
Plum Pink
Yellow Oxide
Storm Blue
black and white graphite paper

Sand the tine gently first, and reread the instructions on the pull-in method (page 26).

Basecoat the lid in Warm White—you will need at least three coats, sanding lightly between each one. Do not paint the handle white.

The bottom of the tine and the handle are basecoated with the Green and Black mix. Make sure you mix enough for two coats. Sand lightly when dry.

Apply the pattern with white graphite paper on the Green/Black area, and with black graphite on the white lid.

The leaves on the lid of the tine are painted in the same

Green and Black mix as the basecoat. Paint these with a No. 3 round brush before painting the roses. The same Green and Black mix is used for the leaves on the bottom of the tine, but add enough Warm White to lighten the colour so it stands out from the background. The overstrokes on the leaves can be added either before or after the roses are completed; again they are done in the Green and Black mix, with the brush wiped in Warm White.

The centres for the roses are placed first, so dabble the centres in with Pine Green plus a little Plum Pink. Try not to overblend as it is nice to have both colours visible. Dry.

To paint the flowers, load a No. 5 round brush with Plum Pink, sideload in Warm White. Holding the white to the inside of the flower, pull comma strokes down to the bottom centre, working from the outside in. You may need to reload for each stroke. For the middle stroke, which should be placed last, the white is held to the bottom.

The lower petals are painted using the pull-in technique. You will need to turn the box so you are working towards your body. Side load a clean brush in Warm White and lay the paint down following the shape of the petal, remembering to do only one petal at a time. Roll off the excess colour and wipe in Plum Pink, flattening out the hairs as you load. Now following the shape of the petal (that is, the way the petal grows), pull the strokes down. Do the same for each petal, always angling the petals down to the calyx or where the calyx would be if it were visible.

Clean the brush and side load in Warm White. Keeping up on the tip, pull tiny comma strokes across the top to represent the petals at the back. Place tiny Yellow Oxide dots in the centre when dry.

Comma strokes on the lid are again done in the Green and Black mix; on the bottom of the tine they are in Warm White. The dot flowers are Yellow Oxide, or Storm Blue with a touch of Warm White.

Antique the finished tine with Retarder and Antiquing Medium plus Raw Umber (see Antiquing, page 14). Make sure the colour is heaviest around the handle and on the edges of the lid, and around the supports on the base. Dry.

Remove any graphite lines and finish with three coats of polyurethane water-based varnish.

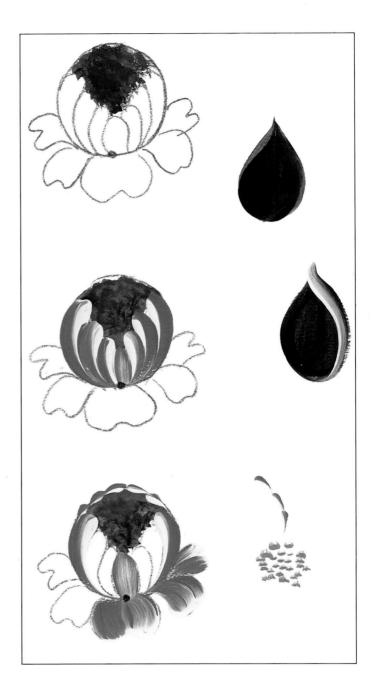

Flour tin

Pattern on page 68

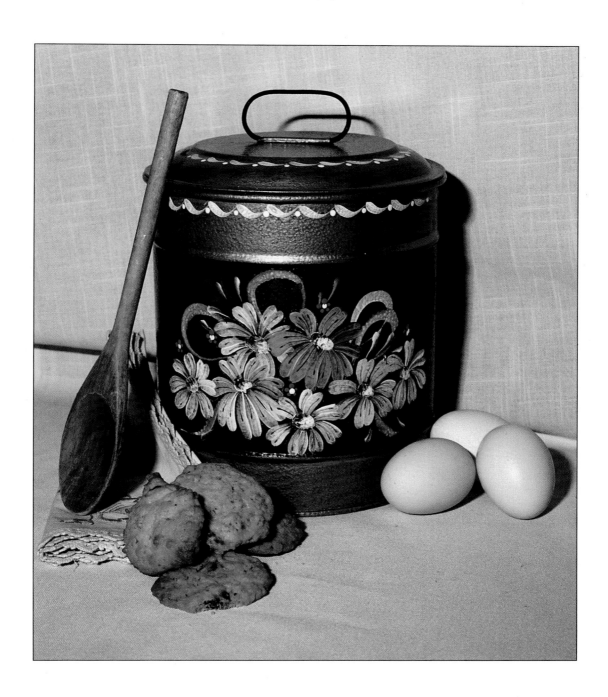

This flour tin is a 50c treasure from a country market. It was in good condition, but to be on the safe side I washed it in a vinegar and water solution and let it dry. I then gave it one coat of Galmet Haloprime. Two coats of Galmet Hammer-It enamel paint were then applied. This wonderful paint simulates the effect produced by hammering sheet metal with a ballpeen hammer and covers up any small dents, scratches or defects in the metal. When thoroughly dry I gave the area to be painted one coat of Jo Sonya All Purpose Sealer.

I used two base colours on this piece, masking off the areas separately.

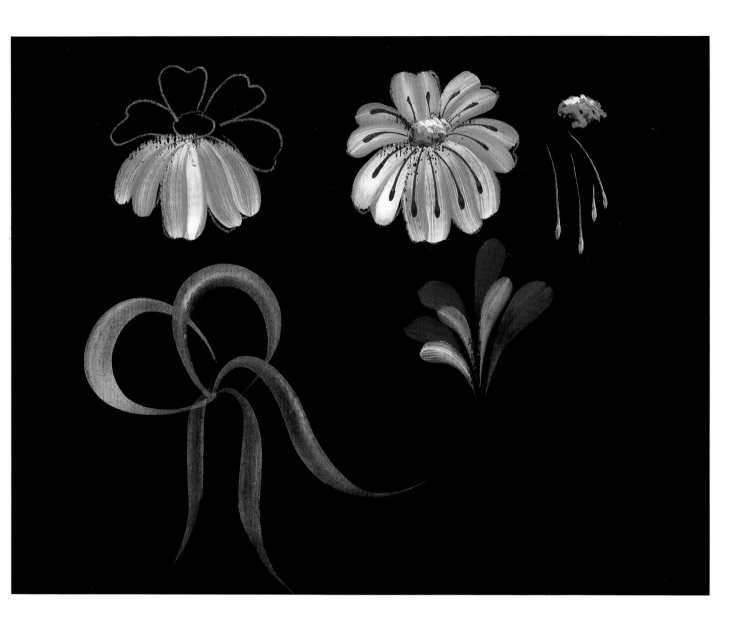

Palette
Galmet Hammer-It in Red Gold and Gunmetal
Americana colours:
 White Wash
 Antique Gold
 Red Iron Oxide
 Avocado
 Williamsburg Blue
 Burnt Umber
white transfer paper
Posterman gold metallic pen (rounded tip)

Using the No. 5 round brush, thin down the White Wash with water to make it transparent. Freehand in the ribbon. Dry. You can chalk it in first if you like, but don't use graphite paper as you won't be able to remove the lines once they have been painted over. Apply the rest of the pattern.

The yellow daisies are painted in Antique Gold and Antique Gold tipped with White Wash. The apricot daisies are Red Iron Oxide tipped with White.

The sit-down strokes on the petals are Red Iron Oxide for the apricot daisies and Burnt Umber for the yellow ones. Do these with the liner brush, remembering to keep up on the tip when starting. The centres for all the daisies are white, dabbled on the side with Burnt Umber.

The comma stroke leaves are Avocado and Avocado tipped in White. Dot flowers are done in Williamsburg Blue with White centres, made with the handle of the brush. The fine comma strokes are in White Wash. The gold lines were applied using the Posterman metallic pen.

When the work is dry remove any graphite lines. Varnish with four coats of Jo Sonya polyurethane varnish for a satin finish, or use Galmet's spray paint in clear gloss acrylic for a shiny finish.

Wooden treasure chest

Pattern on page 70

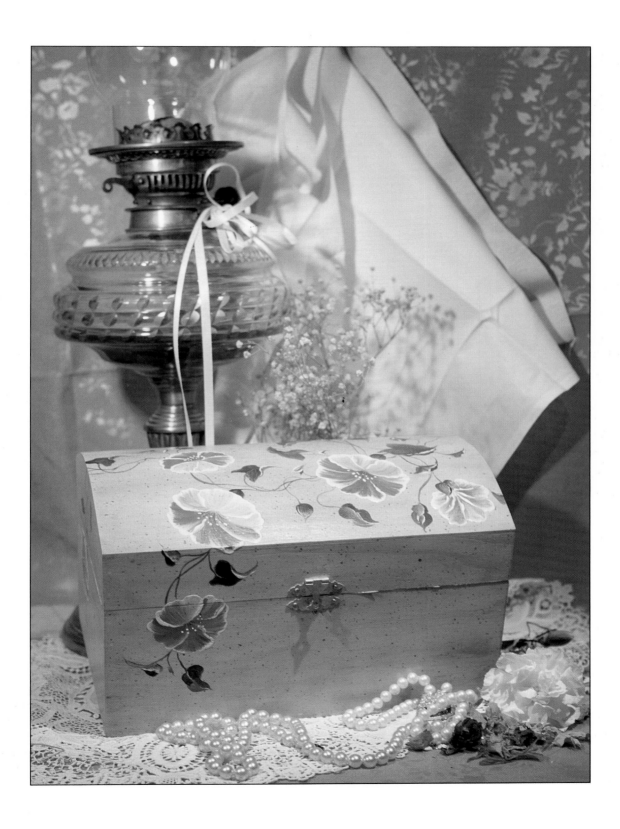

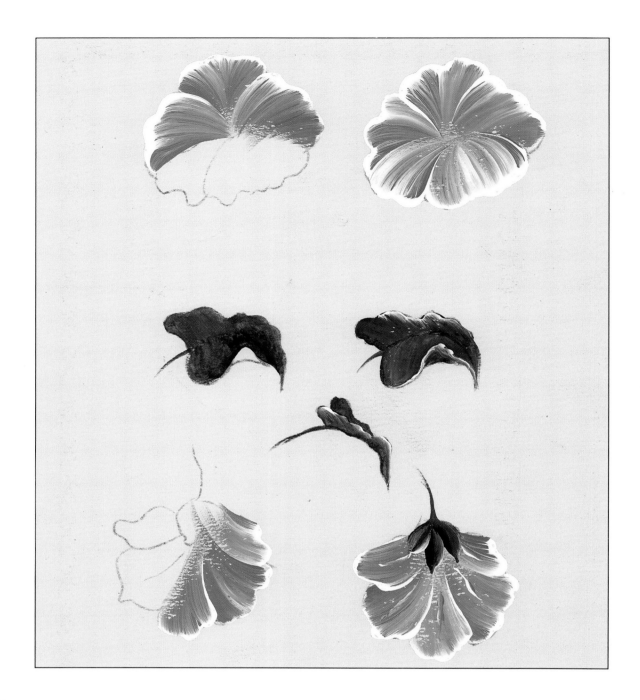

Another Timber Turn product, this wonderful chest has five great painting areas, not including the inside!

Palette (Jo Sonya colours)
Yellow Oxide
Plum Pink
Warm White
Pine Green (with a touch of Carbon Black)
Carbon Black
Aqua
Burgundy
toothbrush

Clear Glazing Medium
Retarder Medium

Fill any nail holes with water putty and sand the box lightly. Mix 3 parts Clear Glazing Medium with 1 part Retarder and enough Warm White to make a soft pickling stain. Test the depth of the colour on a scrap piece of timber; if it isn't white enough add a little more Warm White. It is better to err on the side of caution because you can always recoat. The addition of Retarder to the mix gives you greater working time as it allows the mix to remain 'open'.

Wipe off the excess pickling mix with a clean rag and dry with a hair dryer so you can quickly move onto the next area. When all the areas have been pickled, sand lightly and clean with the tack cloth.

Using a 2.5 cm (1'') flat brush and plain water, moisten one side of the box. Pick up a very small amount of Aqua and streak it over the dampened surface, *with* the grain of the wood. Do the same with the Burgundy. Wipe off the excess, as the idea is to produce a very soft, subtle background. Dry with the hair dryer and move onto the next side. When the whole box has been treated, transfer the pattern lightly with graphite, omitting the stamens.

Leaves and stems With the Green and Black mix on a liner brush, paint in the stems with paint thinned with either water or flow medium to the consistency of Indian ink. Basecoat the leaves with this mix also. Using thicker paint add some shade areas to the leaves, as well as a tint using Plum Pink. Sideload the No. 3 round brush with Warm White and paint the turnbacks on the leaves. Gently pull down some small streaks from the thick ridge of sideloaded Warm White. The buds and calyxes are also painted in this mix. Their veins are painted in thinned Warm White and the Green and Black mix.

Flowers Sideload the No. 5 round brush in Warm White and lay down a thick ridge of paint around the edge of the petal. Work only one petal at a time. Wipe off the excess paint and wipe in Plum Pink, flattening the brush as you load the colour. Now touch the tips of the bristles under the thick ridge and pull all the strokes down to the middle. Try to get the petals at the back of the flower darker. (See pull-in method on page 26.) Repeat for all petals.

It's a good idea to dry each flower with the hair dryer as you finish, as it is so easy to smudge them.

With a small amount of Yellow Oxide in the tip of the brush streak in the centres of the flowers. Using the liner brush and thinned Carbon Black pull tiny stamens out from the centre. Add Warm White dots.

The buds are Plum Pink tipped with Warm White and it's easier to paint the petals before doing the calyxes. Allow to dry and seal with one coat of satin polyurethane finishing varnish.

Make a mix of Burgundy with a touch of Pine Green and thin it down with water. Using an old toothbrush, flyspeck the sides and lid of the box (see page 13). Dry thoroughly and finish with three coats of polyurethane water-based varnish.

Wooden poppy box (29 cm)

Pattern on page 72

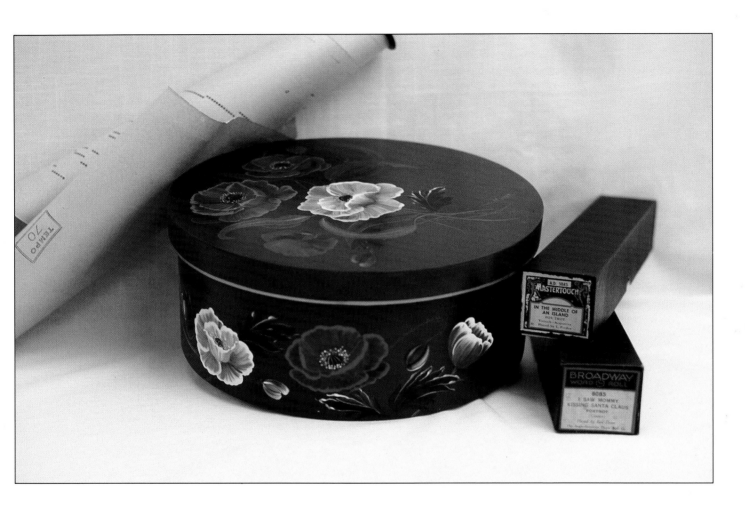

Palette (Jo Sonya colours)

Teal Green } mixed 1:4 to
Raw Sienna } make Hunter Green
Pine Green with a touch of Carbon Black
Warm White
Brown Earth
Raw Umber
Raw Sienna
Napthol Red Light
Napthol Crimson
Yellow Oxide
Gold Oxide
Norwegian Orange
white transfer paper

Basecoat the lid and sides of the box with two coats of the Hunter Green. Sand lightly between coats and apply the pattern using white transfer paper. Don't press too hard or you may dent the surface.

Using the No. 5 round brush and the Green and Black mix, add a little White to make a soft grey-green and basecoat all the gumleaves. Tip the brush in Raw Umber and paint the gumleaves at the back with this. For the front leaves tip the brush in a little White. Try to make them streaky. The centre vein is placed using the soft grey-green for the front leaves and Brown Earth for the back ones.

The poppy leaves are painted in the Green and Black mix with the brush sideloaded in White. The gumleaf stems are the soft grey-green colour, with the brush sideloaded in a paler tint of this (that is, add a little Warm White to the grey-green). The tiny hairs along the poppy stems are also worked in this tint, using the tip of the liner brush and thinning the paint down.

The seed pod is based in with Raw Sienna. Pull in some

Yellow Oxide down one side, Brown Earth down the other, and blend slightly. The depression on the top is also Brown Earth as well as the stripes on the sides.

Before painting the poppies reread the section on the pull-in method (page 26). The same method is used for all poppies.

The red poppies are painted with Napthol Red Light, Napthol Crimson, and Yellow Oxide.

Sideload the No. 5 brush in Napthol Crimson and lay this down along the edge of the petal. Wipe the brush and flatten by pressing gently on the palette. Wipe in Napthol Red Light and pull the strokes down to the middle. Repeat this for all petals, occasionally wiping the brush in Yellow Oxide to bring in some warm tones to a few of the top petals.

The yellow poppies are painted in Yellow Oxide, Raw Sienna, Gold Oxide and Norwegian Orange. The Yellow Oxide is used as the sideload. Put out small puddles of all the colours and wipe through them at random. Try to make the back petals darker by using the darker colours.

The white poppies are painted in Warm White, Yellow Oxide and Raw Sienna. Warm White is used for the sideload. Only small amounts of the other colours are needed, otherwise the poppy will end up too dark.

The poppy buds are painted using the corresponding poppy colour. The flower colour is placed first. Wipe the brush, load in the Green and Black mix, wipe in Warm White and place two comma strokes on either side. Paint the tiny hairs on these outer petals with the tip of the liner brush, using thinned paint.

The poppy centres are worked in Raw Umber with lines of thinned Yellow Oxide. The dots are Yellow Oxide and Warm White. When all is thoroughly dry, antique the box using the oil method (page 13).

Finish with five coats of polyurethane water-based varnish. Using #0000 steel wool, rub very lightly and apply a good quality paste wax such as Busy Bee Beeswax Furniture Polish.

Wooden bird box

Pattern on page 75

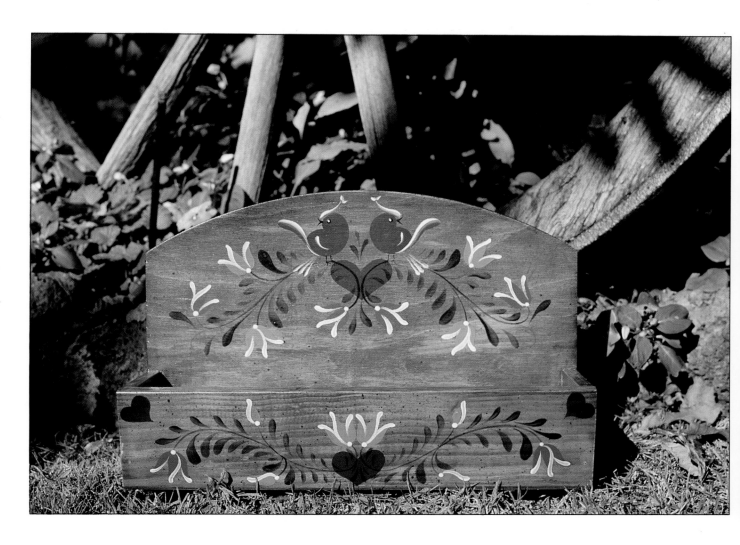

This holder from Timber Turn is great for all sorts of knick-knacks And it's great practice for comma strokes.

Palette (Jo Sonya colours)
Raw Umber ⎫
Raw Sienna ⎬ stain colour
a touch of Pine Green ⎭
Red Earth
Indian Red Oxide
Yellow Oxide
Carbon Black
Sapphire ⎫ 1:1
Storm Blue ⎭ Cadet Blue
Warm White
Clear Glazing Medium

Mix a stain of 1 part Raw Umber, 1 part Raw Sienna plus a touch of Pine Green, with equal parts of Clear Glazing Medium. Using a poly-sponge brush and doing one section at a time, apply a generous covering. Wipe off excess. Allow to dry and sand lightly. Meanwhile mix Raw Umber and a touch of Black and spatter the box inside and out. When dry apply the pattern.

The hearts are based with the Cadet Blue mix.

Base the birds' bodies with Red Earth. Recoat when dry. Dress a No. 5 round brush with Indian Red Oxide and sideload with Warm White to paint the tail, topknot feathers and tail feathers, also the wing on the body. Beak and legs are Carbon Black. For the eye use a dot of Carbon Black with a smaller dot of Warm White on top.

For the stems use the liner brush and thinned Pine Green

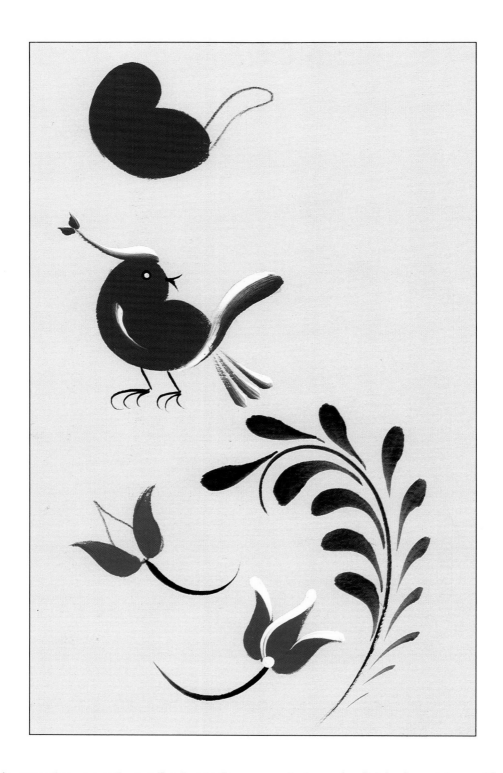

and Black. Paint the stems in one continuous flowing stroke, if you can manage it.

The tulips are painted in Red Earth or Yellow Oxide. The overstroking on the tulips is Warm White.

Comma strokes are Pine Green and Black, dots are Warm White.

Antique the finished container with Raw Umber and Antiquing and Retarder Medium. Let dry and finish with three coats of polyurethane water-based varnish.

Black blossom box

Pattern on page 76

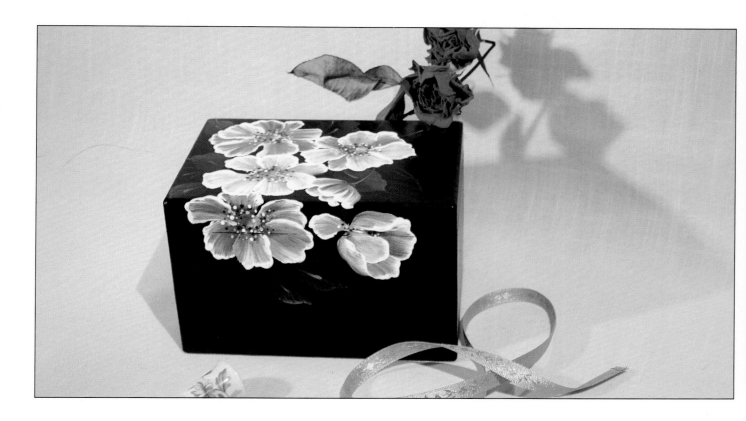

I just love the colours in this little box.

This design carries over the side of the box, which makes it a little more difficult to paint. Have your hair dryer handy.

Palette (Jo Sonya colours)
Indian Red Oxide
Napthol Red Light } (1:1:1) Dark Red
Raw Sienna

Magenta
Raw Sienna } (2:1) Dark Red Violet

Moss Green
Raw Sienna } (2:1) Light Green

Teal
Raw Sienna } (2:1) Dark Green

Turners Yellow
Opal } (1:1) Light Yellow

Gold Oxide
Raw Sienna } (1:1) Dark Yellow

Carbon Black
Turner's Yellow
Titanium White

Basecoat the box in Carbon Black. You will need two coats. Sand lightly when dry. Apply the pattern using light graphite paper. Load the No. 5 brush in the Dark Green mix, wipe in the Light Green mix and paint the leaves. Blend the two slightly.

Check the numbered pattern for the order of painting the blossoms. For the red flowers, lightly load the brush in the Dark Red mix and paint in the base of the petals. Wipe brush. Sideload in White and lay it down following the petal shape. Wipe brush and pull back petals through first. Complete top petals in the same way using the Dark Red Violet mix.

For the yellow blossoms, using the number sequence on the pattern guide, complete back petals with the Dark Yellow mix and the front petals with the Light Yellow mix.

Stems and lines are in the Dark Green mix tipped with the Dark Yellow mix.

Dots are made in Carbon Black, Turner's Yellow and Titanium White.

Antique the completed item with Brown Earth (see section on Antiquing, page 14), and finish with three coats of polyurethane water-based varnish.

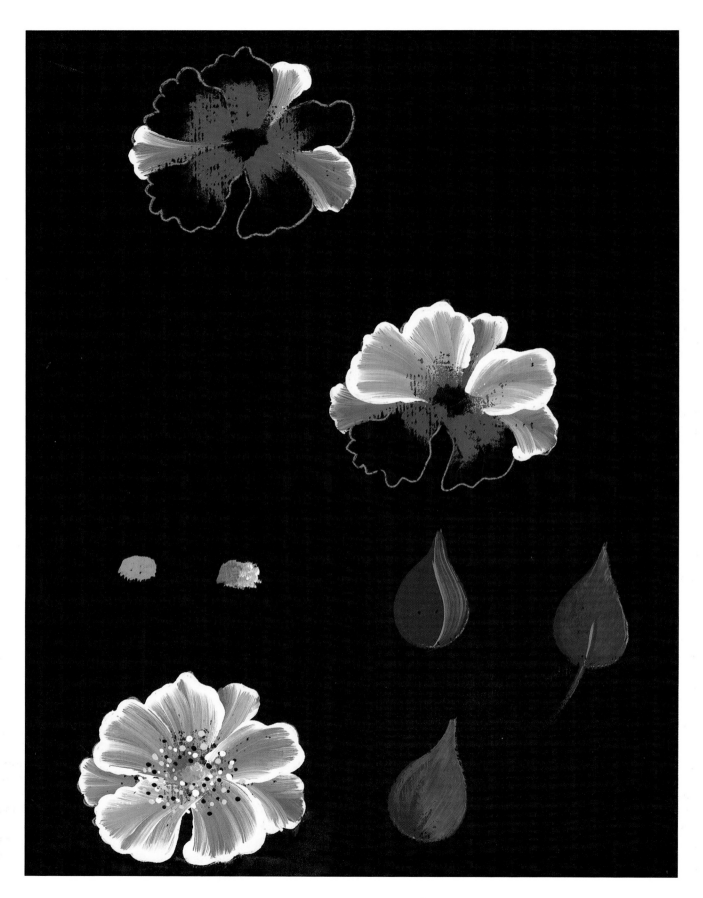

Wooden hand mirror

Pattern on page 77

The pattern is a variation of the small side loaded rose on page 32. Again the approach is very casual. The mirror is available from Timber Turn.

Palette (Folk Art colours)
Teal Green
Blue/Grey Dust
Skintone
Spice Pink
Wicker White
Thicket
Chocolate Cherry
Harvest Gold
black graphite paper

Basecoat the mirror section in Skintone and the handle in Blue/Grey Dust. Recoat. Dry and sand lightly.

Using very watery Teal Green, freehand in the ribbon using a No. 5 round brush. Because the paint is very transparent, graphite lines would show through, so don't apply the pattern yet, although you can lightly sketch in the position of the leaves and roses with chalk if you wish.

Working with thinned down Thicket, place in the leaves, which should be fairly transparent.

Now apply the pattern with graphite paper. Wipe the brush clean and load in Spice Pink, sideloading in Wicker White. Place in the back two petals. Wipe off excess paint and reload in Spice Pink, sideloading in White. Sweep the third petal underneath. Wipe off and reload in both colours as before, and continue placing petals as in diagram.

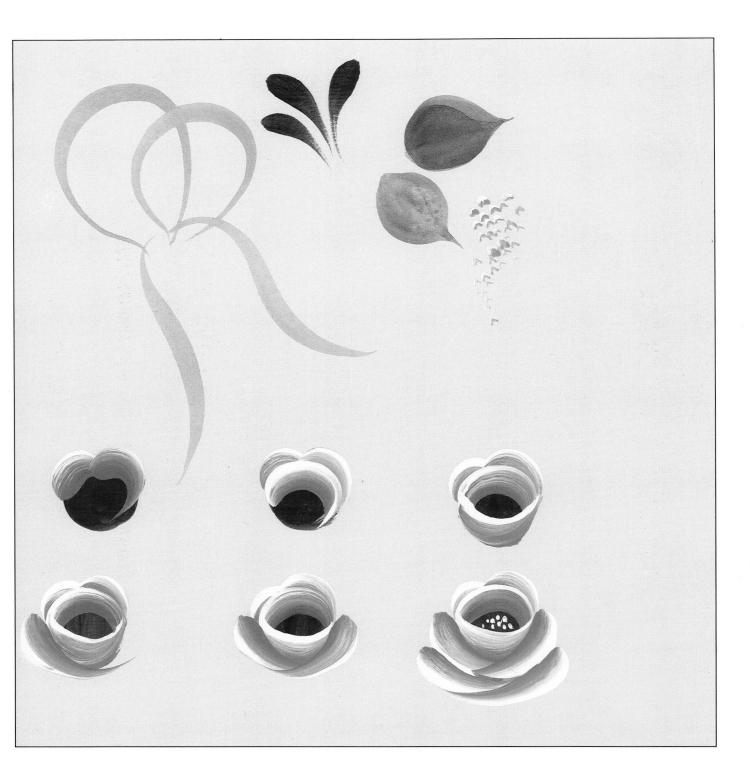

Still using the No. 5 brush, load in Chocolate Cherry, wipe in Wicker White and place in the rosebud centres. Wash the brush, load in Thicket and paint the outer sepals.

Now load the brush in Harvest Gold and wipe in Wicker White. Using only the tip, dab the brush over and over very lightly as filler between the roses. The comma strokes are painted in Thicket, referring to the pattern for placement.

Allow the piece to dry thoroughly. Remove any graphite lines with a kneadable eraser and finish off with three coats of polyurethane water-based varnish.

Blue ribbon coathanger

Pattern on page 77

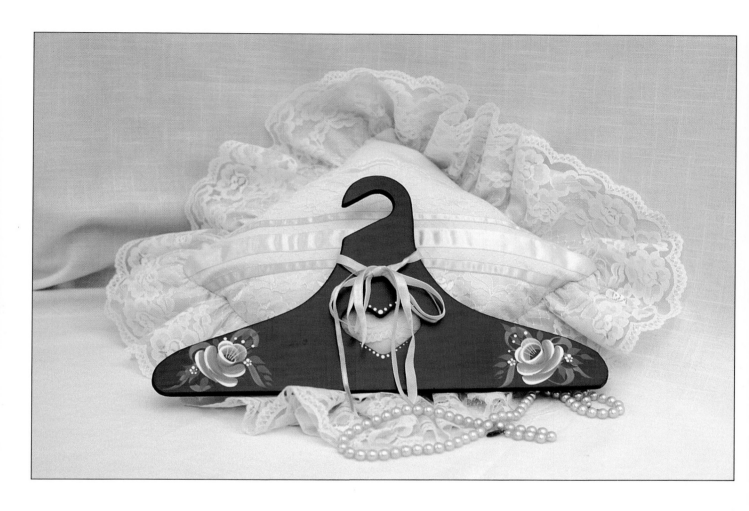

This child's wooden coathanger, again from Timber Turn, would look lovely holding a little girl's dressing gown. It's very simple and quick to complete.

Palette (Folk Art colours)
Teal Green
Chocolate Cherry
Cherokee Rose
Wicker White
Harvest Gold
Bluegrass
Thicket
Jo Sonya Sapphire ⎫
Jo Sonya Storm Blue ⎬ (1:1) Cadet Blue
white graphite paper

Using the Cadet Blue mix basecoat the coathanger. Let dry and recoat. Sand lightly. Using white graphite paper, trace the pattern, omitting dot flowers, stamens and leaves.

Use thinned Teal Green for the ribbon on a No. 5 round brush. Use an eraser first to soften the graphite lines as they might show through the ribbon if they are too dark. Alternatively, draw the ribbon lightly using chalk.

Using the No. 5 brush, paint the central circle of the rose in Chocolate Cherry. Wipe the brush, dress in Cherokee Rose and sideload in Wicker White, and finish the petals as in the diagram. Let dry or speed dry with a hair dryer.

Dots and stamens are painted in Wicker White, thinned for the stamens.

The leaves can be done either freehand or by placing the pattern over the surface once it's dry. Why not try

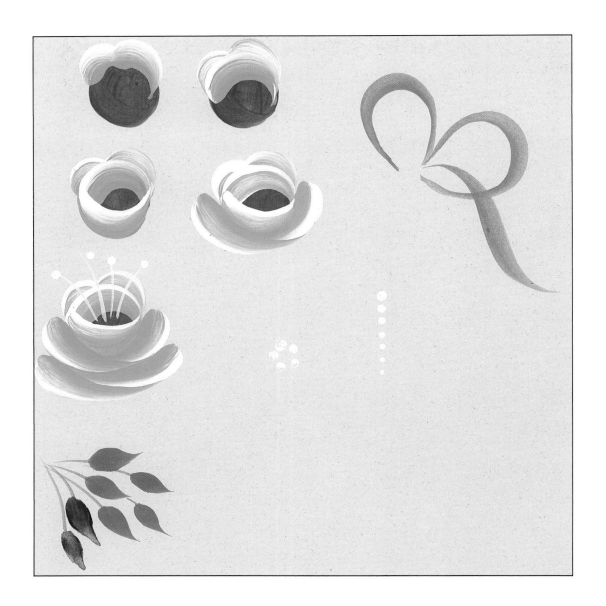

freehanding them? They're done in Bluegrass and Thicket. Load the brush, press down and twist slightly toward the top of the piece. Use the liner brush for the stems. Dot flowers are in Wicker White with Harvest Gold centres.

Remove any graphite lines with a kneadable eraser and finish with three coats of polyurethane water-based varnish.

Wooden utensil holder

Pattern on page 78

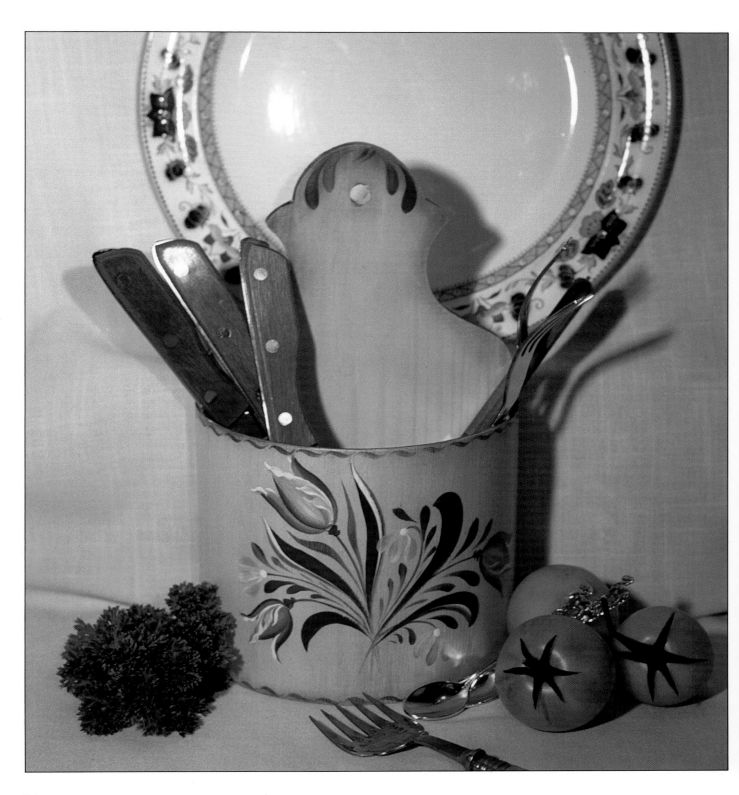

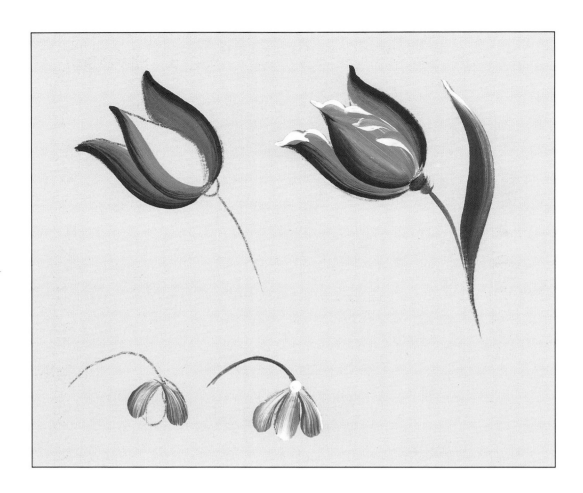

This is another item available from Timber Turn and is so easy to paint.

Palette (Americana colours)
White Wash
Antique Gold
Burnt Umber
Avocado
Red Iron Oxide
Midnite Green
Mississippi Mud
Jo Sonya Clear Glazing Medium
Jo Sonya Retarder
Antiquing Medium
graphite paper

Fill any holes and uneven spots with water-based putty. Sand lightly. The edges may need special attention—move up to a medium grade sandpaper if they feel rough. Finish off with fine sandpaper.

Using Jo Sonya Clear Glazing Medium and White Wash, pickle the surface, including the inside and the back. Work with the grain, wiping off each section as it's completed. (See pickling, page 12). Speed dry with a hair dryer and sand lightly. Transfer the pattern gently, using black graphite paper.

For the central tulip, load a No. 5 round brush with Antique Gold, side load in Burnt Umber and stroke in the outside tulip petals and the left side of the middle petal. Reload in White Wash and place the white overstrokes.

Repeat for the two outside tulips, loading in Red Iron Oxide and side loading with Burnt Umber. The two upper small three-stroke flowers are painted in Antique Gold with the brush tipped in White Wash. The bottom one is Red Iron Oxide tipped in White Wash. Using the liner brush paint in the stems in thinned Avocado. The calyxes are also painted in Avocado.

Mix a little Midnite Green with Avocado to make a darker shade. Using the No. 5 round brush load it well in this mix and paint the large tulip leaves.

The border around the top and bottom of the holder is painted in Avocado. The dots are made in White Wash, using the wooden end of the brush. The comma strokes at the top of the holder are also in Avocado.

Antique the finished piece using Jo Sonya Antiquing Medium and Mississippi Mud. Finish with three coats of polyurethane water-based varnish.

Wooden piecrust plate

Pattern on page 60

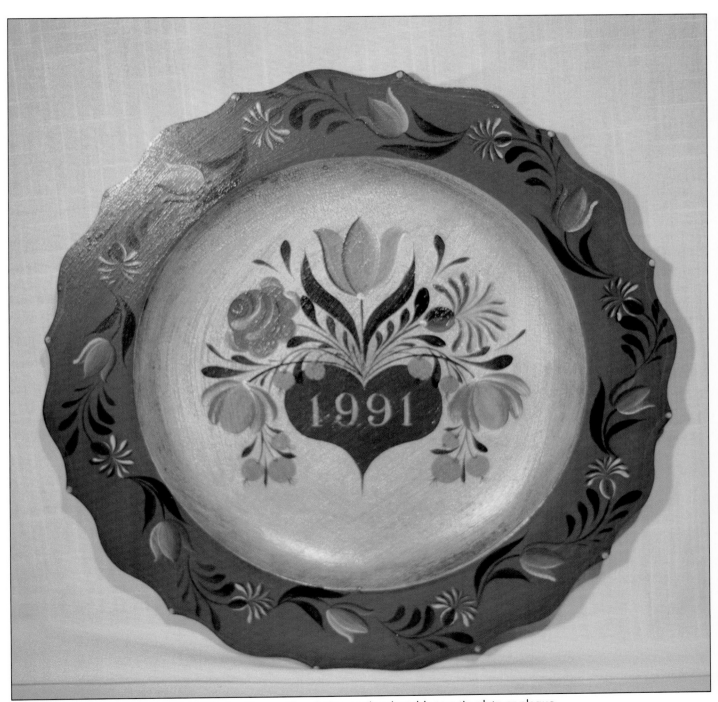

A lovely wooden piecrust plate from Timber Turn, with a design easily adaptable to a tin plate or plaque

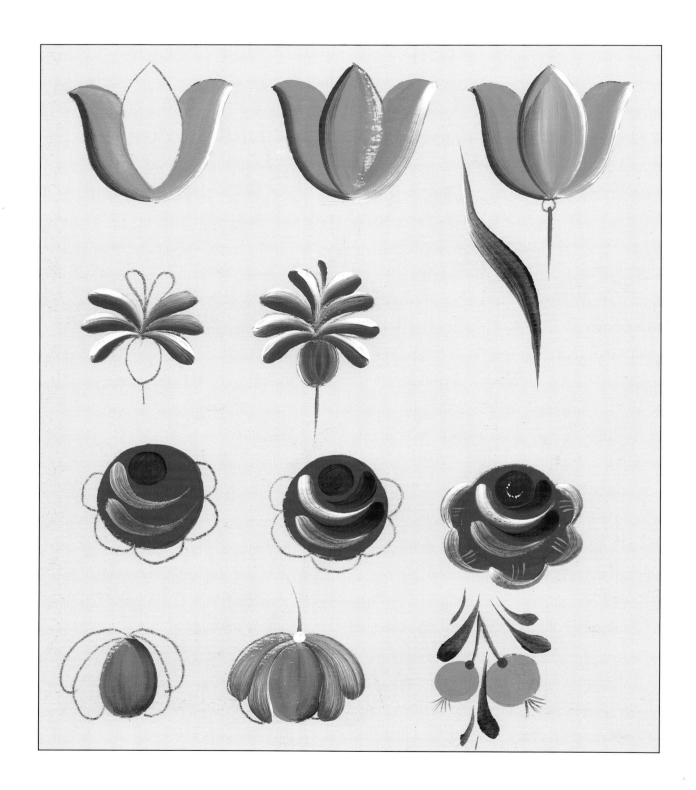

Wooden piecrust plate

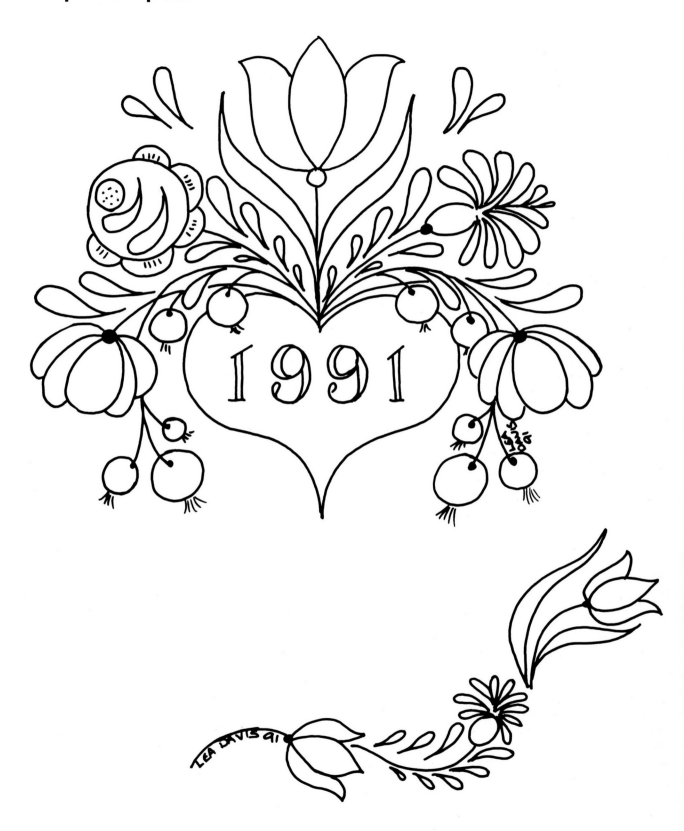

This is a lovely wooden piecrust plate from Timber Turn, but the design could easily be adapted to suit a tin plate or plaque.

Palette (Jo Sonya colours)
Warm White
Burgundy ⎫
Gold Oxide ⎬ (1:) Russet Deep
French Blue
Yellow Oxide
Brown Earth
Red Earth
Raw Umber
Pine Green ⎫
Black ⎬ (4:1) Black and Green mix
Jo Sonya Crackle Medium
Jo Sonya Antiquing Medium
graphite paper

Basecoat the centre of the plate with two or three coats of Warm White. You will probably need to sand lightly between each with old sandpaper. Carefully basecoat the rim twice with Russet Deep. (Leftover mixed paint can be stored in old film canisters.) Sand lightly with old sandpaper. Transfer the pattern with old graphite paper, omitting the comma stroke leaves.

Basecoat the heart with French Blue, smoothing the paint out so there aren't any ridges. Repeat until you are happy with the coverage.

Load the No. 5 round brush in Yellow Oxide, sideload in Brown Earth and stroke in the left outer petal on the tulip, making sure the Brown Earth is to the left. Wipe off, reload in Yellow Oxide and sideload in Brown Earth. Paint half the central petal of the tulip, again having the Brown Earth to the left. Wash the brush, load in Yellow Oxide and sideload in Warm White. Stroke in the right outer petal, making sure the Warm White is held to the right. Repeat for the right side of the central petal. Now blend through the middle of this petal with the White held to the bottom. Don't reload the brush, just use what is left from the last stroke.

Change to a No. 3 round brush and paint the tulips around the edge of the plate, the same as above.

Load the No. 5 round brush in French Blue, sideload in Warm White and place in the comma strokes that make up the carnation. Use French Blue and Warm White for the small carnations around the edge of the plate, using the No. 3 round brush.

Using a No. 2 Liner brush and fairly thin and watery Black and Green, place in all the stems. Keep up on the tip of the brush for nice thin lines. Change to the No. 5 round brush and place the S stroke leaves on either side of the tulip, tipping them in white if you like. Paint the calyx of the carnation with the Black and Green mix also, wiping the brush in the White first.

Load the No. 5 round brush with Yellow Oxide, wipe in Brown Earth, and using three strokes fill in the central oval on the drooping flowers. You need only the smallest amount of Brown Earth on the tip of the brush. Wipe off, reload in Yellow Oxide and basecoat the berries.

Wash the brush, load in Red Earth, tip in Warm White and pull comma stroke petals on either side of the drooping flowers. Wash the brush, reload in Red Earth and base in the circle for the body of the rose. Let dry. Load the brush in Brown Earth and paint in the small circle. Pull comma strokes across the body of the rose, also in Brown Earth. Clean the brush, load in Warm White and pull comma strokes across the other side, making sure the tails tuck in between the Brown Earth commas. Wash the brush, reload in Brown Earth and pull five petals around the outside of the rose. Overstroke them with Warm White commas. Tiny Warm White lines on each petal and Warm White dots in the small Brown Earth circle finish this easy rose.

Now load the No. 5 round brush in the Black and Green mix and paint in all commas and S strokes. Using the liner brush, pull tiny lines from the bottom of the berries in Pine Green.

Using thinned Yellow Oxide and the liner brush, run a line around the outside edge of the plate.

For the date use thinned Warm White and the liner brush and freehand in the numbers. You may wish to include a name as well. Let dry.

Lastly, place in all the dots using the handle end of the brush:

Berries—Red Earth
Tulip and Carnation calyxes—Warm White
Drooping flowers—Warm White

Now apply one thick coat of Crackle Medium, brushing it out as evenly as possible. You will still have some brush marks (I like it that way), but they can be sanded when dry if you prefer. You may speed dry the crackle medium with a hair dryer—this will result in ragged-edged crinkly cracks. (See Crackling on page 13.)

You can go ahead and sand when the surface is dry. Use 400/600 wet-and-dry sandpaper to remove any ridges. Blow off the excess sanding dust and wipe gently with a damp cloth. Mix 1:1 Retarder and Antiquing Medium and Raw Umber and spread evenly over the plate. Wipe off the excess with a clean cloth. The medium will seep into the cracks, giving the plate an aged appearance. Allow at least five days before varnishing with three coats of Jo Sonya water-based polyurethane varnish.

PATTERNS

Easy wooden rocking horse

Page 28

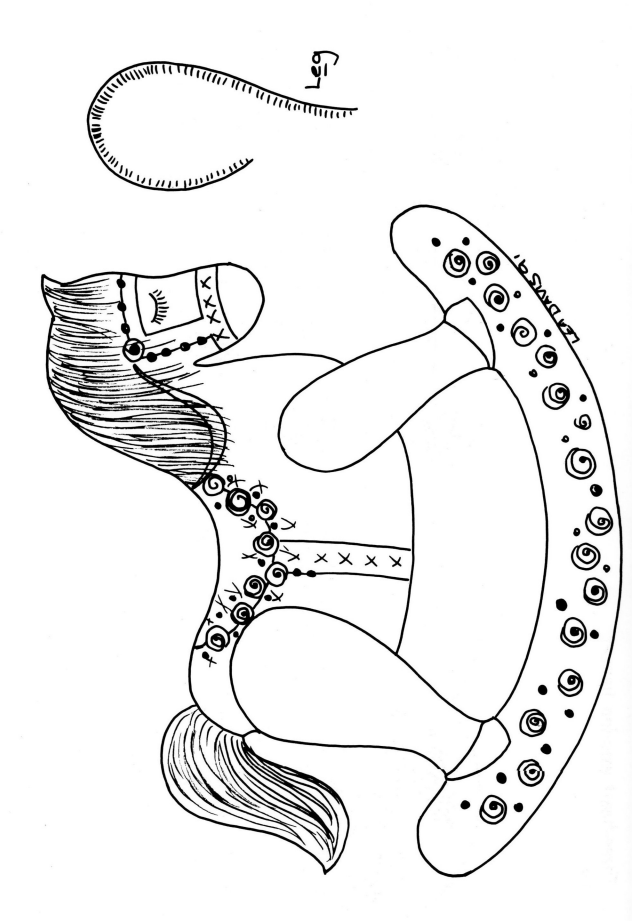

Leg

Three-heart wooden hanger

Page 34

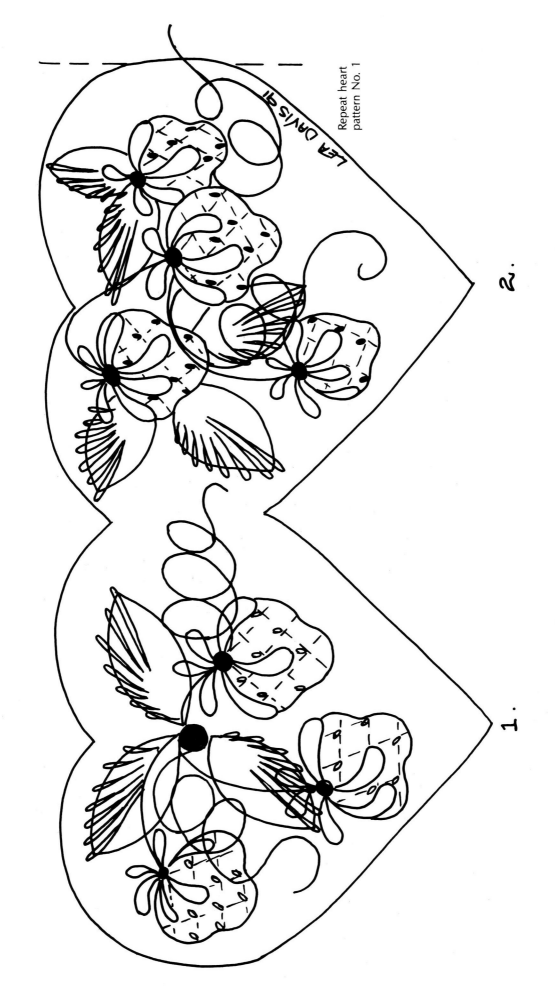

LEA DAVIS 91

Repeat heart
pattern No. 1

2.

1.

63

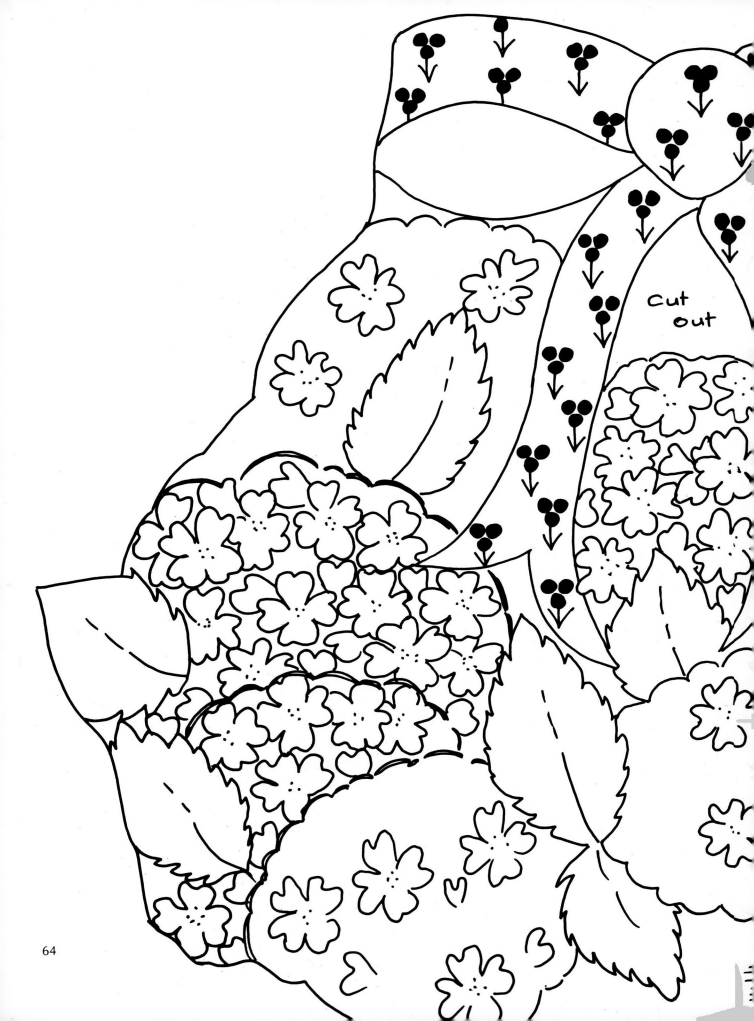

Cut
out

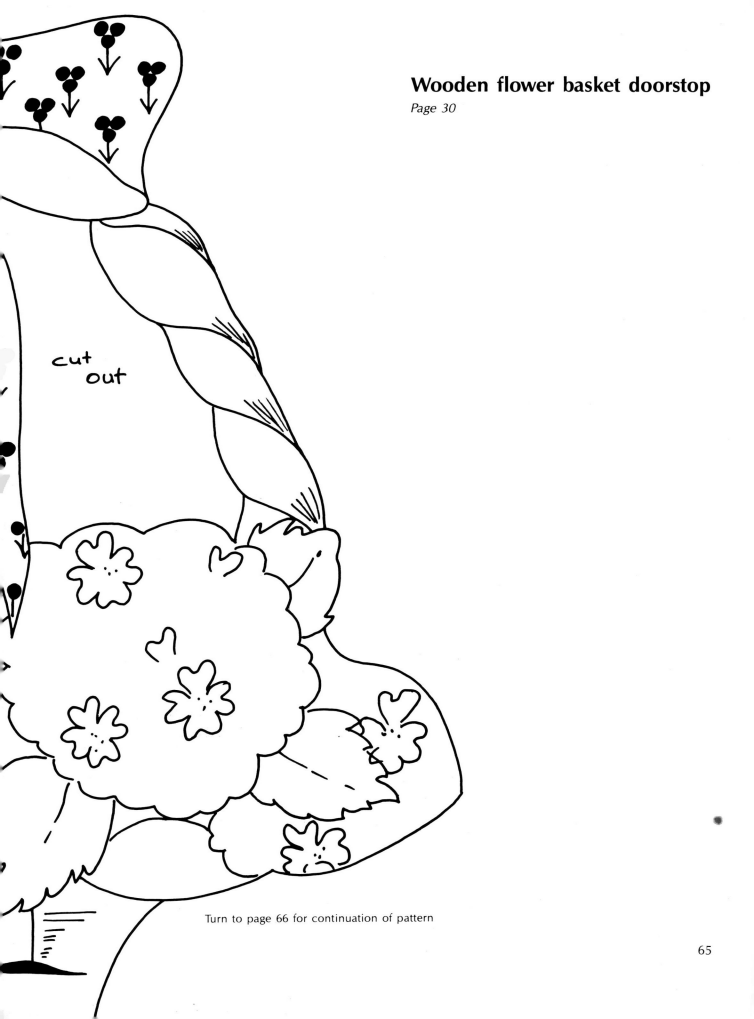

cut
out

Turn to page 66 for continuation of pattern

Continuation of Flower basket doorstop pattern

Join on
line .

LEA DAVIS 91

Ring of roses wooden box

Page 32

LE DAVIS
91

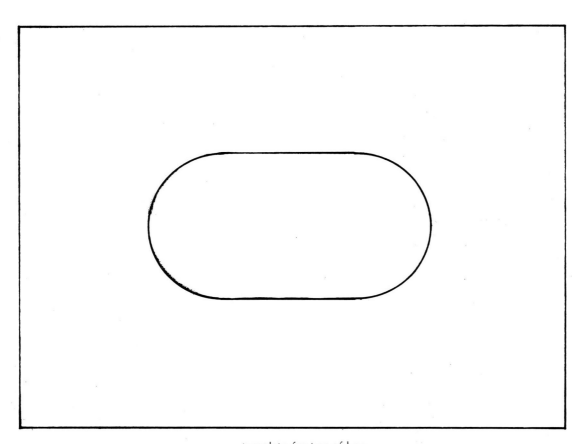

template for top of box

Terracotta pansy pot

Page 36

Flour tin

Page 40

Oval wooden tine

Page 38

Wooden treasure chest

Page 42

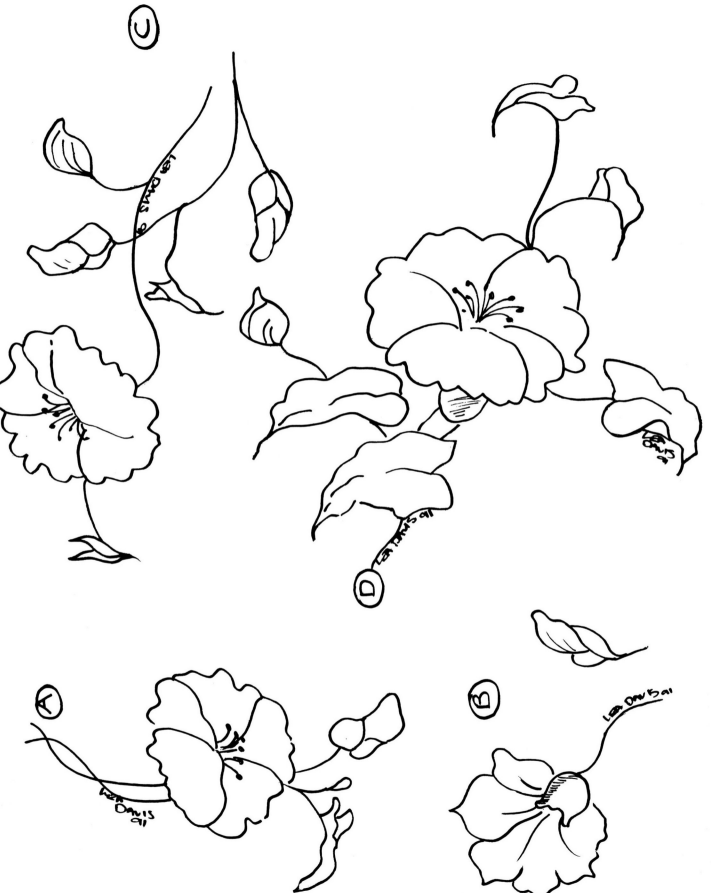

Lid

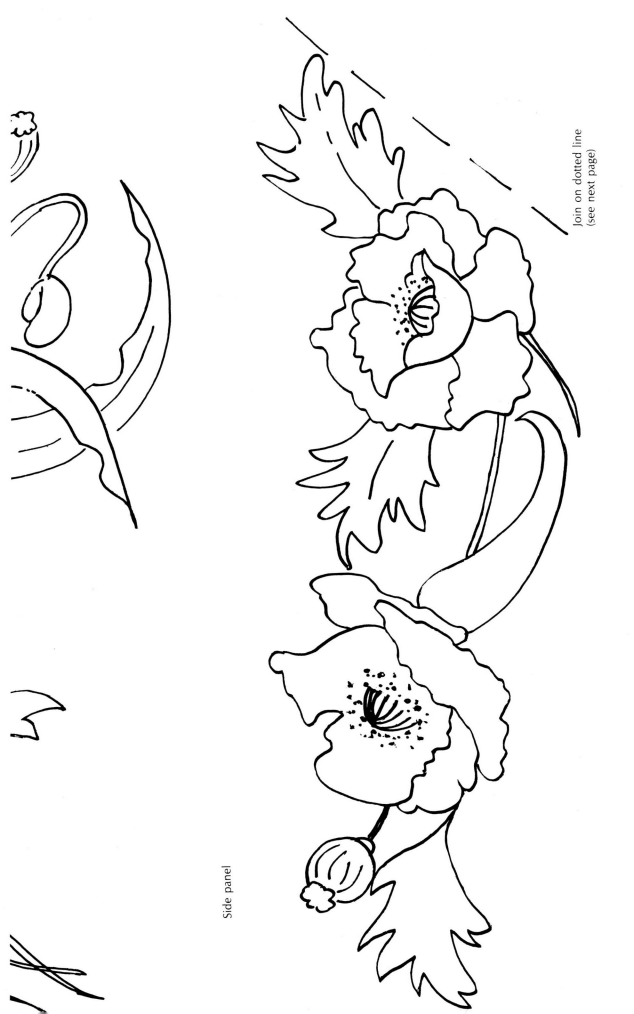

Side panel

Join on dotted line
(see next page)

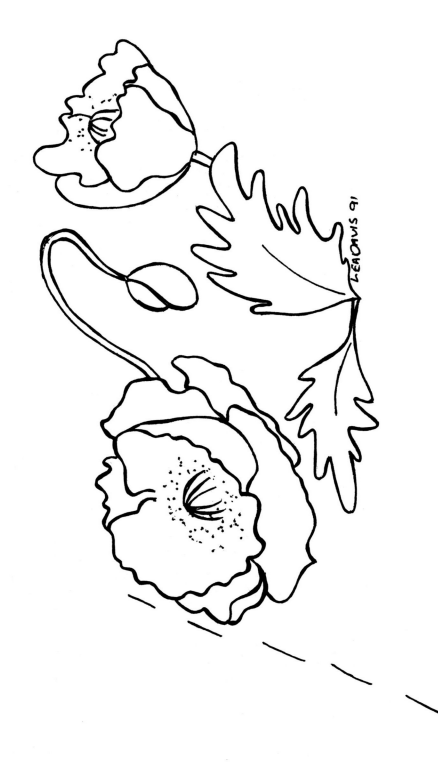

Continuation of side panel for wooden poppy box

Wooden bird box

Page 48

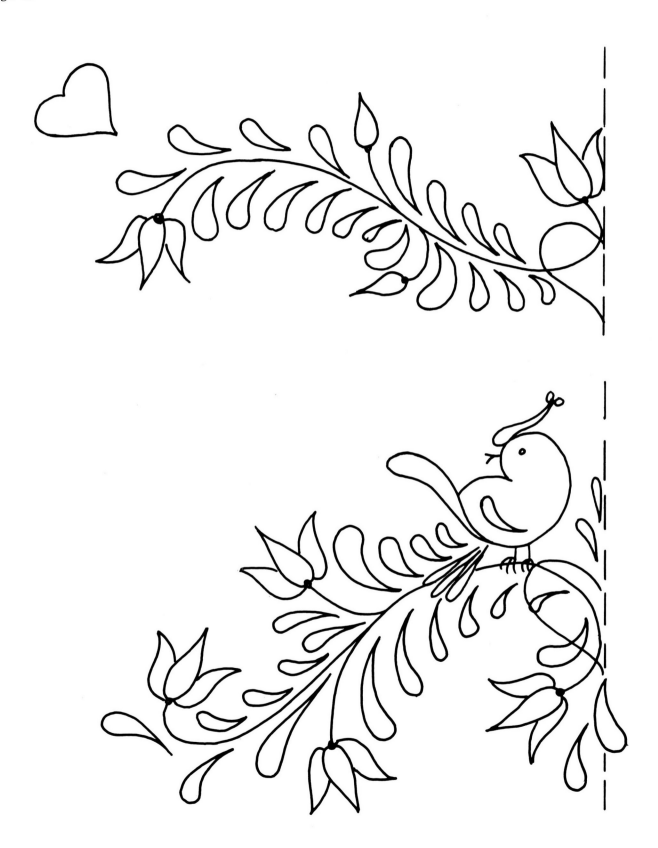

Black blossom box

Page 50

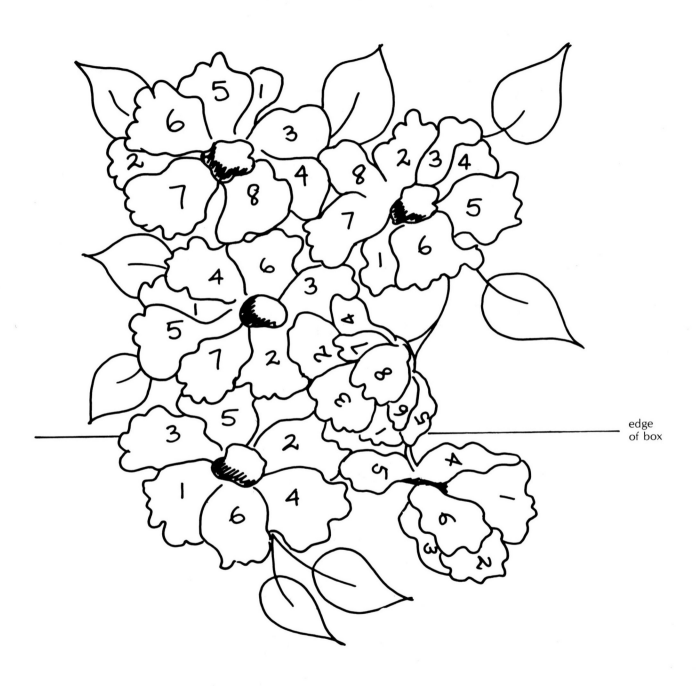

edge
of box

76

Wooden hand mirror

Page 52

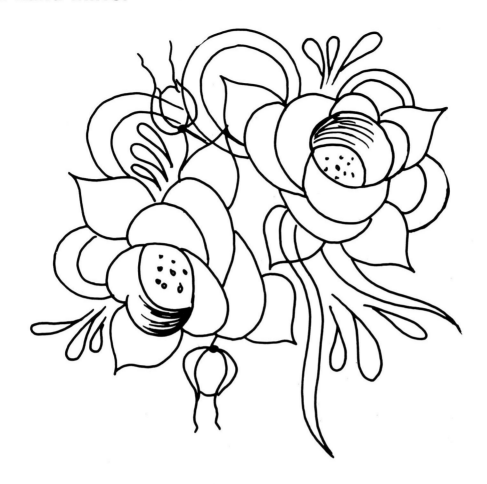

Blue ribbon coathanger

Page 54

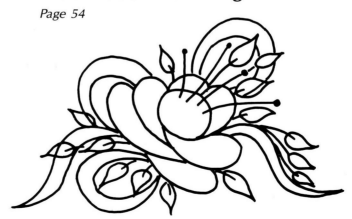

Wooden utensil holder

Page 56

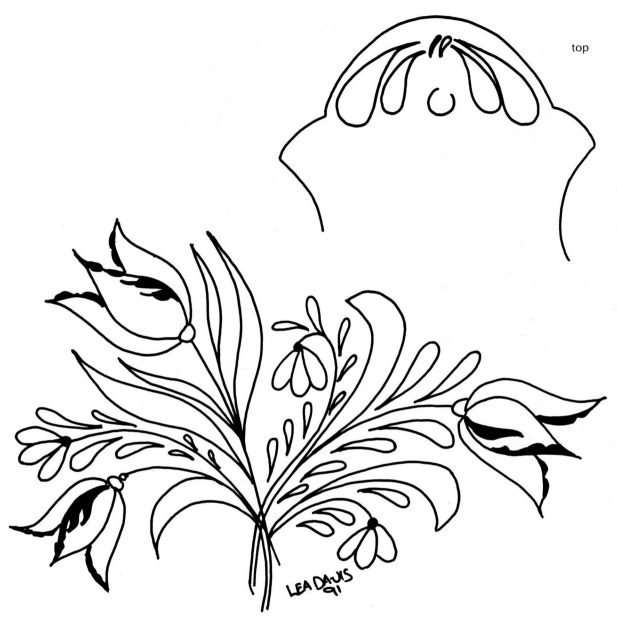

top

Suppliers

Craft stores for:
 Jo Sonya products
 Varnishes
 Brushes
 Brush cleaner
 Transfer and graphite paper
 Posterman Metallic Water-Based
 Pigment Pen in Gold or Silver
 Americana paints
 Folk Art paints

Hardware stores for:
 Busy Bee Beeswax Furniture
 Polish (paste wax)
 Tack cloth
 Sandpaper
 Galmet Zip Strip (paint stripper)
 Haloprime (metal primer)
 Ironize CS (rust killer)
 Epoxy Rust Paint
 (Call Galmet on 008 226262
 for your nearest stockist of
 these last four items if they
 are hard to find)

Addresses:
Lea's Folk Art Studio
(Lea Davis)
51 Rosella Street
Murrumbeena Vic. 3163
(03) 568-0802

Country Folk Art Connection
9 High St
(PO Box 550)
Woodend Vic. 3442
(054) 27-1267

Timber Turn Woodturners and
Manufacturers
1 Shepley Ave
Panorama SA 5041
(08) 277-5056

Woolbrook Cottage Crafts
Balmoral Rd
Cavendish Vic. 3408
(055) 74-2287

Paulines Folk Art Supplies
8 Montefiore St
Norwood Tas. 7250
(003) 44-3806

The Painted Touch Folk and
Decorative Art Studio
411 Bay St
Brighton Vic. 3186
(03) 596-3690

Folk Art Tol'd
891–893 Mt Dandenong Rd
Montrose Vic. 3765
(03) 728-4687

Galmet Paints
53 Mitchell Rd
Brookvale NSW 2100
(008) 22-6262 (02) 905-0696

Victoria Academy of Decorative
Arts
369 Camberwell Rd
Camberwell Vic. 3124
(03) 882-7082

Leanne Milhano Folk Art Centre
1 Bartholomew St
Richmond SA 5033
(08) 234-5443

Decorative Folk Art Supplies
Cnr Port and Woodville Rds
Woodville SA 5011
(08) 347-2922

Elsa's Folk Art Studio
12 Myrtle St
Normanhurst NSW 2076
(02) 484-5447

The Folk Art Studio Pty Ltd
178 Sydney Rd
Fairlight NSW 2094
(02) 949-7818

Marshiles Craft Centre
22 Stuart St
Devonport Tas. 7310
(004) 24-6171

Cottage Art and Craft
43 Cattley St
Burnie Tas. 7320
(004) 31-1332

Craftee Cottage
Shop 29, Station Square
Oakleigh Vic. 3166
(03) 568-3606

Folk Art Academy of Australia
PO Box 5540 CMC
Cairns Qld. 4870
(070) 34-1106

Index